IMAGES
of America

BALTIMORE'S PATTERSON PARK

Tim Almaguer on behalf of
the Friends of Patt...

D1370379

Join us for a book signing on
January 27th at 2:00 p.m.

ARCADIA
PUBLISHING

IMAGES
of America

BALTIMORE'S
PATTERSON PARK

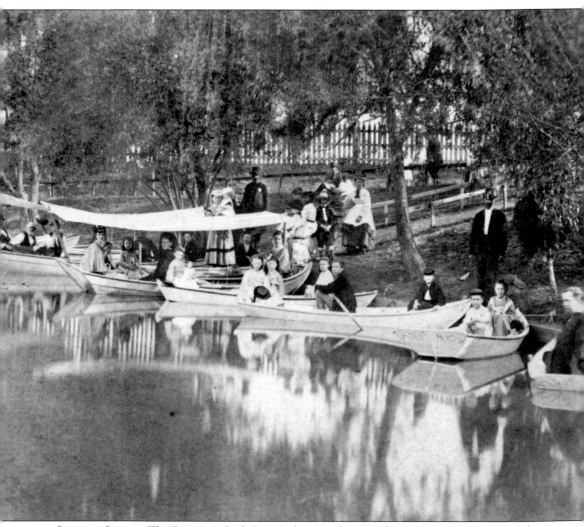

ON THE COVER: The Patterson Park Boat Lake, seen here in the 1890s, was a common place for Baltimoreans to rent boats to row around the two-acre lake. As Baltimore grew as an urban center, such spaces became more important to the neighborhoods.

IMAGES
of America

BALTIMORE'S
PATTERSON PARK

Tim Almaguer on behalf of
the Friends of Patterson Park

Mary,
Please enjoy the book & the
park

27 Jan '07

Tim Almaguer

ARCADIA
PUBLISHING

Published by Arcadia Publishing
Charleston SC, Chicago IL, Portsmouth NH, San Francisco CA

Printed in the United States of America

Library of Congress Catalog Card Number: 2006931585

For all general information contact Arcadia Publishing at:
Telephone 843-853-2070
Fax 843-853-0044
E-mail sales@arcadiapublishing.com
For customer service and orders:
Toll-Free 1-888-313-2665

Visit us on the Internet at www.arcadiapublishing.com

To all the friends of and visitors to Patterson Park.

CONTENTS

ACKNOWLEDGMENTS

I am truly blessed to have been raised in Baltimore, a city with such rich history, wonderful people, great parks, and noble institutions. I would like to thank everyone at the Enoch Pratt Free Library, Baltimore County Library, the Jewish Museum of Maryland, National Parks Service at Fort McHenry, the Friends of Patterson Park, the Friends of Maryland Olmsted Parks and Landscapes, the Commission for Historical and Architectural Preservation, and the Baltimore City Department of Recreation and Parks.

I am extremely fortunate to have such great friends who have helped me with this book: Eric Holcomb; Scott Sheads; Ed Schull; Sandy Sparks; Anna Santana and her great photographs of the park she loves so much; Jeff Korman; Richard Parsons; Danyelle Dorsey; everyone who donated old family pictures (the Supik family, R. V. Miller, Elva Chachulski, and so many more); all the Friends of Patterson Park, especially Nancy Supik, Lesley Gardiner, Caryn Horrigan, and Callie Schwartz; and the lovely Kyle Kessenich, without whose understanding, support, and editing (with some giggles) I could not have written this book.

I have been inspired by so many people, namely my grandfather Mario Almaguer Sr., who during the Depression was a young Tex-Mex boy from San Antonio who worked in the Civilian Conservation Corps' "Tree Army" in Arizona. His stories of working on open pristine land led me to do the same. Thank you to my mentors, great people like Nancy Supik and Chris Delaporte, who believe that parks should always be fun, public, inclusive, and accessible to everyone.

Neither this book nor the park would be possible without the great stories and hard work. Thank you to all those who have made Patterson Park what it is through their enjoyment. Thanks to all the volunteers who have helped Patterson Park when it was down and all those who keep it moving forward—you rock!

INTRODUCTION

What is a park? In today's urban environment, it is rare green space seemingly cut from the asphalt and bricks, an anomaly in and contrast to the fast-paced world and congested streets of the city. A park is a place for everyone and a place for oneself, providing baseball fields for teams and shady trees for reading a book. Parks are inclusive spaces for everyone to freely enter. Parks are the landscape where children learn how to ride a bike, throw a Frisbee, or catch a fish; where adults meet and talk about politics or the Orioles; where the elderly walk the pathways of their youth, listen to music, and teach their grandchildren how to sled down "Cannon ball hill."

In writing this book, I have consistently noticed one thing: the rationale for the existence for parks has not changed over time nor has the need for parks. There has always been a need for a cool and relaxing landscape for the mind and spirit, a place to come together, a field in which to run and catch. Each era had its motive for creating and further developing Patterson Park. Whether the reason was to set aside land for the common people, to entice development and home buying, to clean the air of miasma and disease, or to meet friends and have your first kiss, these reasons have remained constant. In the mid-19th century, the conflict between the industrial era and a pastoral nostalgia brought us city parks that were illusionary and separate from urban living, while the Progressive Era of the early 20th century saw parks as utilitarian facilities to better the quality of life for the working class. Today Patterson Park fulfills Baltimore's need for both.

In the past 30 years, parks nationwide have suffered from neglect and under-funding. Meanwhile, the need for parks has increased. Childhood diabetes and obesity are on the rise, adult heart disease is ever increasing, and juvenile crime is infecting more and more neighborhoods. Public parks and recreational activities have a role in reducing these human and societal ailments. These same aims were held during Baltimore's recreational movement at the start of the 20th century. Parks are also being seen as environmental buffers, which impede the progress of urban run-off from impermeable surfaces like streets and sidewalks, which leads into our watersheds. In the Gilded Age, this was similar to the belief that parks were the "lungs of the city" that not only provided some environmental assistance but also helped to reduce "miasma" or vapors that cause diseases.

From the very beginning, Baltimore has been a diverse city with many ethnic groups. Parks were often the central feature to new immigrant communities and their early American experience. Today we see a similar experience. New immigrants from Eastern Europe, Africa, and Latin America are coming into Patterson Park and sharing the community's common green space, like the pre–Civil War Irish and Germans had done and the early-20th-century Polish, Czechs, Ukrainians, and Russian Jews as well.

This book is about the story of Patterson Park. This history contains not only the dates and facts but also the chronicle of the relationship between land and people in southeast Baltimore. Generations have sat beneath Patterson Park's trees, played tag, or walked slowly around the Boat Lake. This connection to the land was what inspired a Baltimore volunteer militia 12,000 strong to build a series of small fortifications on Hampstead Hill to stop the British in 1814. It was also

the force that motivated people to develop a public park system in Baltimore in 1860; to provide free baths and playgrounds in the early 1900s; to sit next to the Conservatory with family to "catch up on things," to learn how to ride a bike on a brick park pathway, to band together and create a plan for park improvements, and to volunteer to keep the park clean and safe. There are over 180 pictures of Patterson Park in this book, that is, lithographs from 1814 to digital pictures taken in 2006. Though you may not see your own photograph in these pages, I am sure you will see your own experiences reflected in the pictures.

Enjoy and hope to see you in the park!
Tim Almaguer

All pictures are from the archives of the Friends of Patterson Park except for those with credits. The author's proceeds from this book will help support Patterson Park activities.

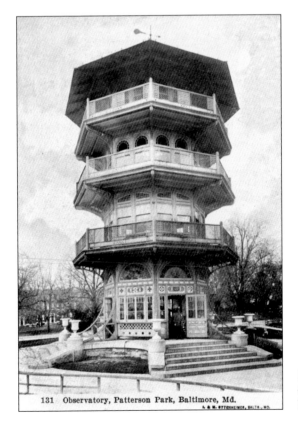

131 Observatory, Patterson Park, Baltimore, Md.
L & M. OTTENHEIMER, BALTO., MD.

Pictured is the Patterson Park Observatory "Pagoda" built in 1891, seen here in 1911.

8

One

FROM FARM TO PASTORAL PARK

Patterson Park is blessed with picturesque landscapes and a rich history. The park has been witness to Baltimore's development into a major city, beginning with the Colonial wheat fields along Harris Creek, to the battlements against invading British troops during the War of 1812, to the Civil War encampment during Baltimore's secessionist fever. The park has remained while events have occurred in and around it.

In 1667, colonists piloted their boats into the river valley of Harris Creek, an estuary off the Patapsco River. Drawn by the promise of 50 acres of land, Quinton Parker claimed his stake as "Parker's Haven," Patterson Park today. Later in 1708, the farmland was purchased by Nicholas Rogers, who owned a larger tract of land to the northwest called "Hab Nab at a Venture," what is now Druid Hill Park. Unfortunately the Rogers family fell upon hard times, and in 1792, the sheriff auctioned the Rogerses' Harris Creek farm to pay off the family's debt. The highest bidder was William Patterson, an Irish immigrant who had supplied the American Revolutionary Army with weapons and had become a wealthy Baltimore merchant.

William Patterson's acquisition proved to be a strategic location in September 1814. The U.S. Capitol was ablaze as President Madison was fleeing Washington, D.C. Marauding British troops marched freely through the fledgling nation's capital and easily took D.C. when Gen. Robert Ross then turned his eyes to Baltimore, the city that harbored the privateers, which had troubled the British fleet. By water, the British entered the Patapsco River and bombarded Fort McHenry and by land amassed forces at North Point ready to march into Baltimore to repeat their fiery rage. Immediately General Ross was fatally shot from his horse, and as his troops marched toward Baltimore, they saw on a high hill 100 cannons and 12,000 soldiers, mostly volunteer militia. This was Rodger's Bastion (now Patterson Park). Seeing the opposition and having made few strides, the British returned to their ships and left.

On April 19, 1827, William Patterson presented the City of Baltimore and Mayor Jacob Small with six acres of his property as a "public walk." This gift to his beloved adopted city was the beginning of Patterson Park.

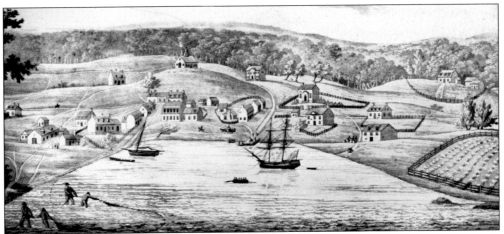

In 1668, the 550-acre Cole Harbor was divided in two by the "currents" of Jones Falls. This land was the beginnings of Baltimore. To the east, Quinton Parker was given land on Collett's Creek (later Harris Creek) to farm. Throughout Colonial Baltimore, farms grew tobacco and corn. Parker's Haven was on land that today is Patterson Park. This lithograph depicts Baltimore's harbor in 1752.

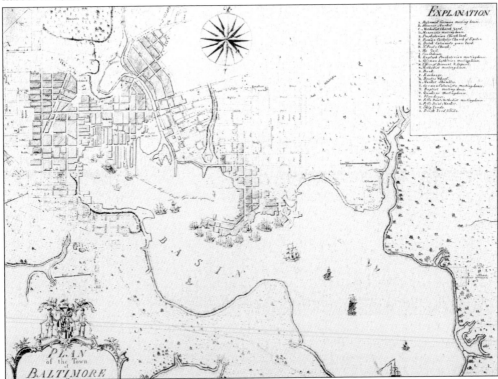

In 1708, Nicholas Rogers purchased both Parker's Haven and Kemp's Addition for £25. On April 26, 1781, British warships were seen entering the Patapsco River. Both Benjamin Rogers and his cousin Col. Nicholas Rogers, friend and aide to Marquis de Lafayette, were members of Baltimore's Defense Committee. Defenses of Baltimore were built on the highest point of the Rogers property, Hampstead Hill. Here is Baltimore's harbor in 1792 with Harris Creek to the east. (Courtesy of the Enoch Pratt Free Library, Baltimore.)

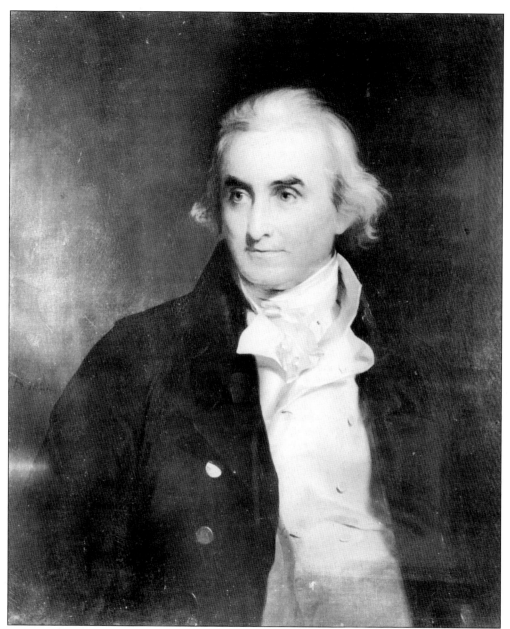

William Patterson was born in Fanat, County Donegal, Ireland, in 1752. When he was 14, he was sent to Philadelphia to learn the merchant shipping industry. At the onset of the American Revolution, Patterson began to supply the Revolutionary Army with arms and supplies that were spirited through the British blockade from the West Indies. In 1778, he moved to Baltimore to continue his mercantile business. He helped fund Marquis de Lafayette's Yorktown campaign against the British and joined the forces on the peninsula as a member of the 1st Baltimore Cavalry. In 1799, Patterson help to raise funds for the completion of Fort McHenry and helped to gather supplies for its defense in 1814. William Patterson become the first president of the Bank of Maryland and was one of the incorporators of the Baltimore and Ohio (B&O) Railroad in 1827 and of the Canton Company in 1828. (Courtesy of the Enoch Pratt Free Library, Baltimore.)

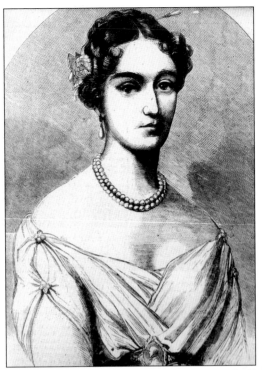

William Patterson and his wife, Dorcas Spear, had 13 children. Elizabeth "Betsy" Patterson was one of their beautiful young daughters. The Patterson family often entertained foreign dignitaries; it was at one of these formal parties that she met Jerome Bonaparte, a young French naval officer and the brother of Napoleon Bonaparte. On Christmas Eve 1803, 18-year-old Betsy and 19-year-old Jerome were married. (Courtesy of the Enoch Pratt Free Library, Baltimore.)

Within a year, Napoleon Bonaparte, ruler of the French empire, had the marriage annulled. Young Jerome was sent to northwestern Germany, where he was given the title of King of Westphalia (1807–1813)—however, not before a child, Jerome Napoleon Bonaparte, was born to Betsy Patterson on July 7, 1805, in Camberwell, London, England. This romantic story became a worldwide scandal. (Courtesy of the Enoch Pratt Free Library, Baltimore.)

In October 1808, the young American nation still held ire toward Britain, especially in the merchant city of Baltimore. A ship from Holland carrying gin docked in Baltimore's port. The vessel had passed through an English port, where it was taxed at a high rate. The gin cargo was taken to Hampstead Hill (Patterson Park today), where it was burned in protest to English taxation. This became know as the Baltimore Gin Riot.

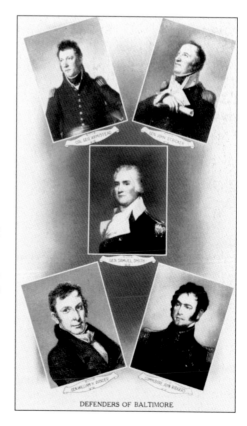

Baltimore was fast becoming known as an international port. More and more, it was getting the reputation as being bitterly anti-British. On June 18, 1812, the United States declared war on England in order to preserve American free trade and sailors' rights. Baltimore and the Chesapeake Bay became central to the war efforts. The Patterson property neighbored the Canton waterfront. Here is a montage of "Baltimore's Defenders" during the Battle of Baltimore, from left to right: (top) Col. George Armistead and Gen. John Stricker; (middle) Gen. Samuel Smith; (bottom) Gen. William Wilder and Commodore John Rodgers.

DEFENDERS OF BALTIMORE

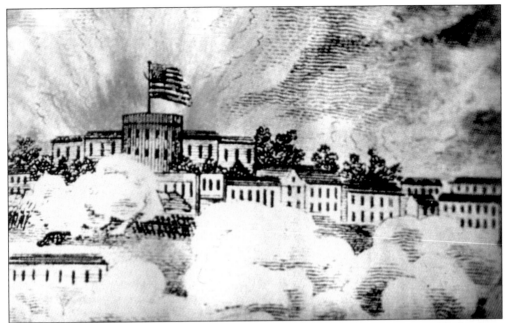

On August 24, 1814, the British army defeated an overwhelmed American army at Bladensburg and promptly marched into the nation's capital of Washington, D.C., where the British burned and looted the U.S. Capitol and several government buildings, as depicted in this sketch from 1814. Pres. James Madison was forced to flee to Brookeville, Maryland. Next the British looked north to Baltimore. (Courtesy of the National Park Service at Fort McHenry.)

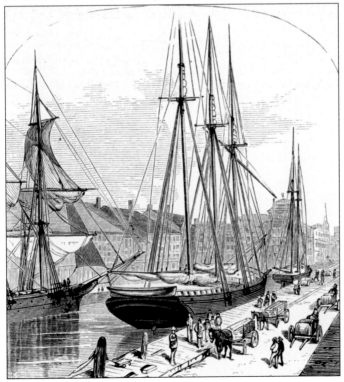

Baltimore not only was a busting port but was also home to privateer ships, fast-moving clippers that became the scourge of the British merchant fleet. The Baltimore clippers overran and seized British cargo and sold the good at foreign ports. The *London Times* proclaimed Baltimore as the "nest of pirates." These ships sustained Baltimore's economy during the British blockade. The British army wished to destroy Baltimore's "pirate" fleet.

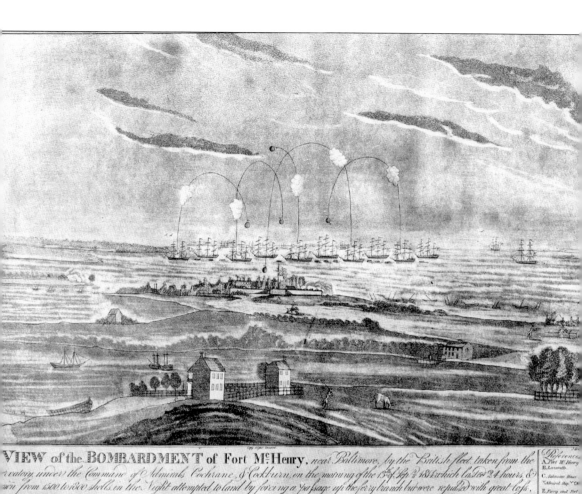

VIEW of the BOMBARDMENT of Fort Mc.Henry, near Baltimore, by the British fleet taken from the *...vatory, under the Command of Admirals Cochrane & Cockburn, on the morning of the 13th of Sepr 1814 which lasted 24 hours, & ...wn from 1500 to 1800 shells in the Night attempted to land by forcing a passage up the ferry branch but were repulsed with great loss.*

References.
A.Fort McHenry.
B.Lazaretto.
C.Salisbury House
—Admirals Ship "On"
E.Ferry and Fort.

On September 12, 1814, the British, under the command of Maj. Gen. Robert Ross, landed over 5,000 troops at North Point, east of Baltimore. The plan was for the British naval fleet to sail past Fort McHenry and enter the basin to bombard Baltimore. This would support General Ross's troops as they burned and looted Baltimore, as they had easily done in Washington, D.C. From North Point, the British would move westward toward Baltimore and burn the "pirate" fleet. (Courtesy of the Enoch Pratt Free Library, Baltimore.)

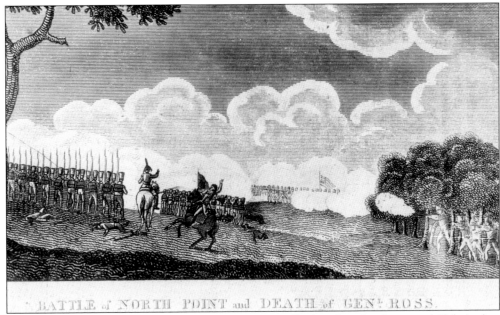

BATTLE of NORTH POINT and DEATH of GEN. ROSS.

At the Battle of North Point, General Ross was mortally shot from his horse and Col. Arthur Brooke took over his command. The Americans retreated, and the British followed them within a few miles of the city. The Baltimore defenses were under the command of Maj. Gen. Samuel Smith, an officer of the Maryland militia and U.S. senator. (Courtesy of the Enoch Pratt Free Library, Baltimore.)

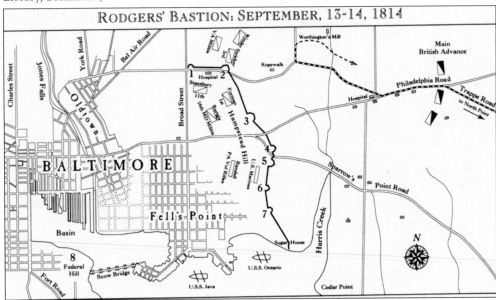

Approaching Baltimore, the British encountered American troops on Hampstead Hill (today Patterson Park). On this hill were 12,000 members of Maryland's militia and Baltimore volunteers. They had entrenched themselves in a series of redoubts (seen here) with over 100 naval cannons. This became known as Rodgers' Bastion, named after the redoubt's commander, Commodore John Rodgers. In a thunderstorm, the British waited for their navy to subdue Fort McHenry. (Courtesy of the National Park Service at Fort McHenry.)

The British navy was unable to defeat Maj. George Armistead at Fort McHenry. Hampstead Hill's stand seemed very foreboding for the British army, causing Colonel Brooke to withdraw his troops and flee Baltimore. The Battle of Baltimore was one of the turning points in the War of 1812. Meanwhile, a young lawyer, Francis Scott Key, wrote a poem describing the bombardment that would become our national anthem. (Courtesy of the Enoch Pratt Free Library, Baltimore.)

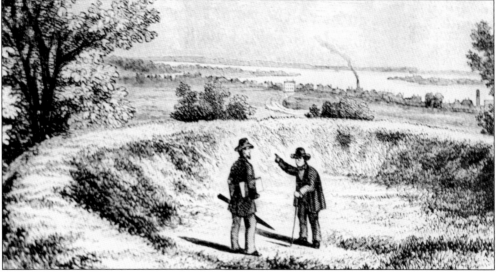

Hampstead Hill or Rodger's Bastion immediately became a historical site dedicated to the brave Baltimore volunteers who protected Baltimore from British aggression. The redoubts remained as a reminder of the fortifications and became a central feature of William Patterson's property. (Courtesy of the Baltimore County Public Library.)

In 1827, William Patterson donated six acres of his property in the southeast of Baltimore as a "public walk." Having seen many European parks, Patterson knew that such green spaces help to create community and would entice people to buy houses on his neighboring properties. His own estate was called Coldstream northwest of his park. (Courtesy of the Enoch Pratt Free Library, Baltimore.)

At the age of 83, William Patterson died in Baltimore. Patterson left a will that served as his autobiography and provided funds for the small park's maintenance. William Patterson was buried at their family site near Coldstream. His daughter, Betsy, was not buried with the family. (Courtesy of the Enoch Pratt Free Library, Baltimore.)

On July 13, 1853, Baltimore City formally introduced Patterson Park as a public park. The celebration brought a crowd of over 20,000 and had fireworks and a concert by the Independent Blues. A battery with large cannons similar to the one at Rodger's Bastion fired a salute. Nighttime boating was a special event in this new park.

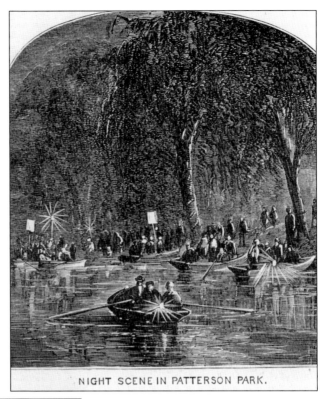

NIGHT SCENE IN PATTERSON PARK.

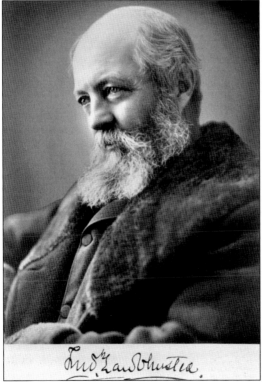

During the middle of the 19th century, two forces collided: the genesis of urbanization due to the Industrial Age and the naturalistic movements of art and philosophy. The synergy of these new realities influenced landscape architects such as Andrew Jackson Downing, Claude Vaux, and Frederick Law Olmsted Sr. (seen here), who began to build urban parks. In Baltimore, it was John H. B. Latrobe who developed parks with a similar ideal. (Courtesy of the Friends of Maryland Olmsted Parks and Landscapes.)

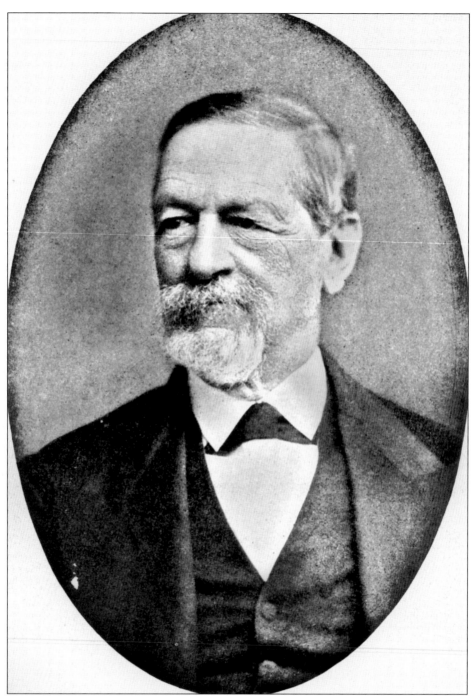

John H. B. Latrobe (1803–1891) was the son of Benjamin H. Latrobe Sr., architect of the U.S. Capitol and Baltimore's basilica. John H. B. Latrobe was a renaissance thinker. He had become a prominent Baltimore lawyer for the B&O Railroad but also painted watercolors and wrote poetry, invented a stove and heater, founded the Maryland Historical Society, and was a philanthropist to the arts. In 1860, Mayor Thomas Swann asked Latrobe to serve on a board of park commissioners who would develop Baltimore's new parks and landscapes.

Mayor Thomas Swann (1806–1883) saw the need to weave green spaces into the burgeoning bricks and mortar, so he strove to find and create new public parks. In order to pay for this accession of land, Mayor Swann enacted an ordinance that would mandate that the new horse-drawn railway system pay one-fifth of its income for the purchase and maintenance of public parks. (Courtesy of the Enoch Pratt Free Library.)

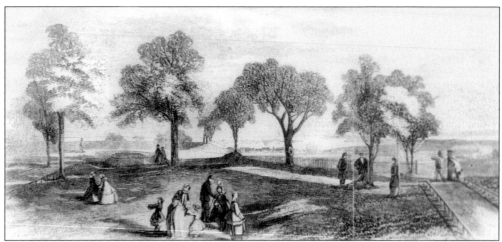

In 1860, Baltimore City purchased 29 acres from the Patterson family to enlarge Patterson Park. To the west, J. H. B. Latrobe and the other park commissioners had purchased a larger tract of land from the Rogers estate, calling it Druid Hill Park. Plans were developed to build on these parks, but in 1861, Union encampments were placed on these parklands. Patterson Park is seen here in *Frank Leslie's Illustrated Weekly* of 1861. (Courtesy of the Enoch Pratt Free Library.)

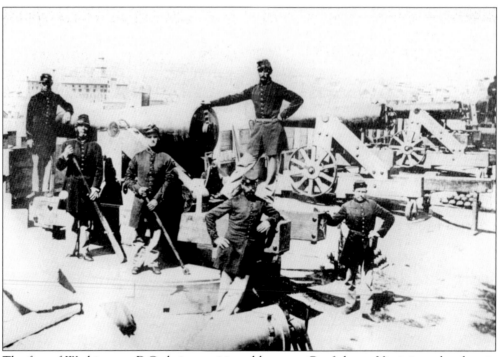

The fear of Washington, D.C., being positioned between Confederate Virginia and a chaotic Baltimore prompted Gen. Benjamin Butler to lead Union troops north to Baltimore to occupy the city and keep the peace. Martial law was declared, and troops were dispersed throughout the city. Seen here are Union troops on Federal Hill with cannons pointed at Baltimore. (Courtesy of the Baltimore County Library.)

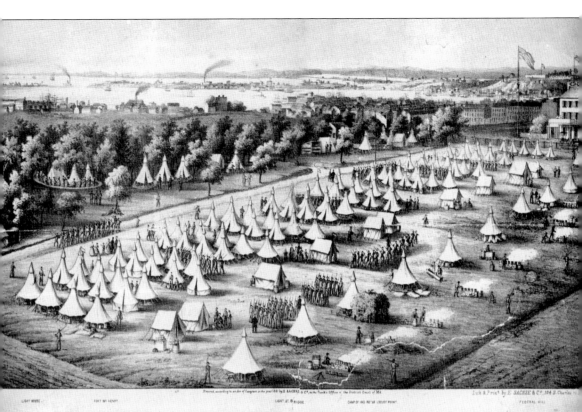

CAMP OF THE 7. M^D. V. RG^T. PATTERSON PARK, BALTIMORE, Md.

COL. MARSHALL.

On April 12, 1861, Fort Sumter was shelled by Confederate batteries at Charleston Harbor. The American Civil War had begun. A week later on April 19, Union troops from Massachusetts and Pennsylvania arrived at Baltimore's President Street Station to march across town to Camden Station on their way to protect Washington, D.C. An angry pro-secessionist mob descended on the troops and shots rang out. This became know as the Pratt Street Riots and was the site of the first fatalities of the Civil War. In the end, 4 soldiers and 12 civilians were killed. On May 13, 1861, Union troops entered Baltimore to stay. Baltimore mayor George W. Brown, the Baltimore City Council, and George P. Kane, marshal of the Baltimore City Police, were arrested and sent to Fort McHenry. Seen here is Camp Patterson Park in 1861.

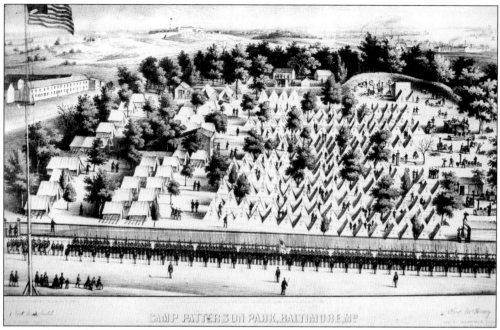

During the Civil War, several Baltimore parks were sites of Union troop encampments. Patterson Park was no exception. Such encampments were intended not only to protect Baltimore from a Confederate invasion, but more importantly, to keep Baltimore from seceding from the Union. Many in Baltimore had "Secessionist Fever." Camp Patterson Park is seen here. (Courtesy of the Enoch Pratt Free Library, Baltimore.)

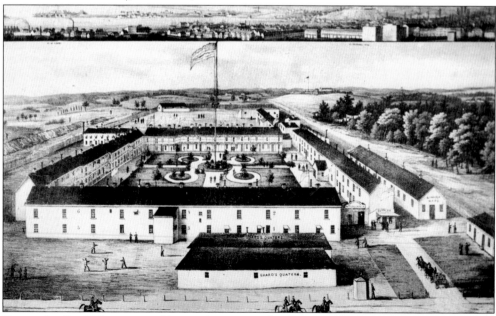

During the Civil War, a surgical hospital was erected in Patterson Park. The hospital was named Camp Washburn (Fort Number 12) after the then-governor of Maine, Israel Washburn. The 10th Maine Regiment was the first to occupy Patterson Park under Col. George L. Beal. (Courtesy of the Enoch Pratt Free Library, Baltimore.)

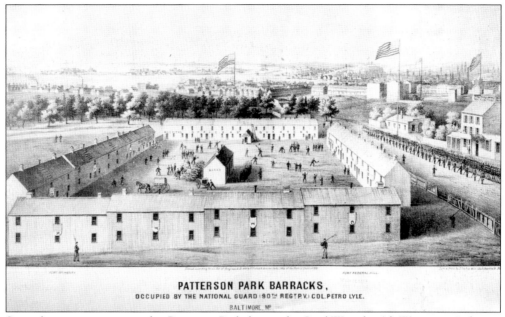

PATTERSON PARK BARRACKS,
OCCUPIED BY THE NATIONAL GUARD (90TH REG'T P.V.) COL. PETRO LYLE.
BALTIMORE, MD.

Several regiments encamped at Patterson Park during the Civil War: the 6th Wisconsin Infantry, 159th Ohio Infantry, 7th and 10th Maine Regiments, 110th Regular New York Volunteers, 3rd Maryland Infantry, and 19th Pennsylvania Infantry. After the war, many of these same troops stayed in Baltimore and raised families, many of which still remain in the neighborhood. (Courtesy of the Enoch Pratt Free Library, Baltimore.)

Camp Washburn was a full surgical facility having over 1,000 beds. Many from the Battle of Gettysburg convalesced here after the bloody battle. Seen here is an original hospital requisition form for clothes dated June 18, 1864.

25

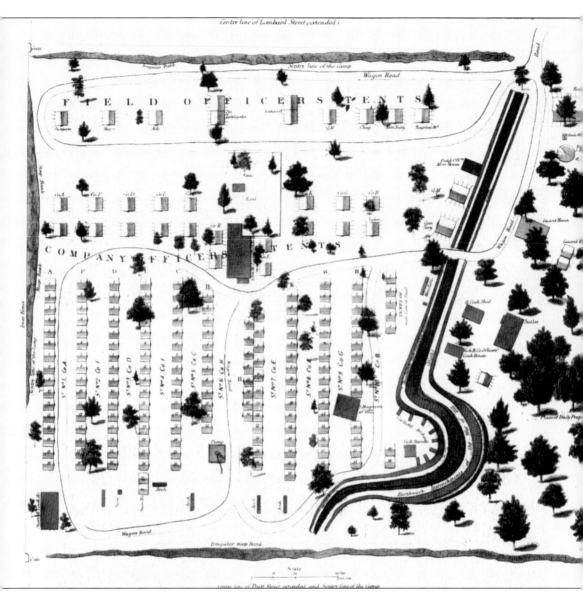

Many soldiers stationed in Camp Patterson Park wrote letters to their loved ones. A rifleman from the 6th Wisconsin Volunteer Company, Howard J. Huntington, describes how local pro-secessionists called the Plug-Uglies attacked the Union encampment at midnight and that he and his fellow troops fired back: "The Chesapeake Bay is near us and the beautiful city of Baltimore almost surrounds us. . . . We had just executed the order when a bullet hissed passed my ear. . . . There was some firing and a cow and one secessionist killed." In July 1863, he and his regiment, the Wisconsin Iron Brigade, would fight and be wounded at Gettysburg.

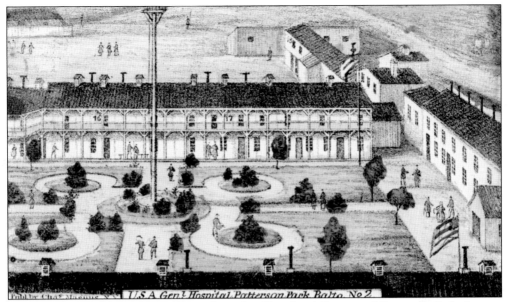

The large surgical hospital was located north of Lombard Street and Patterson Park Avenue (once called Pinckney and Gist Streets respectively). In 1864, the hospital and encampment were disbanded and all military buildings razed. As described in the parks report at the time, much of the remaining livestock broke through temporary fences and ran through the streets, and the once lush and green landscape was barren and brown.

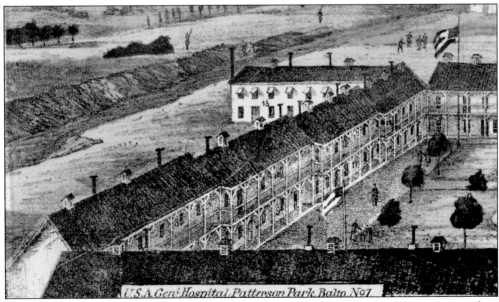

These images of the Union encampment at Patterson Park are actually writing paper and an envelope that were used by the soldiers in the encampment to send not only correspondence but also a scene from where they were stationed.

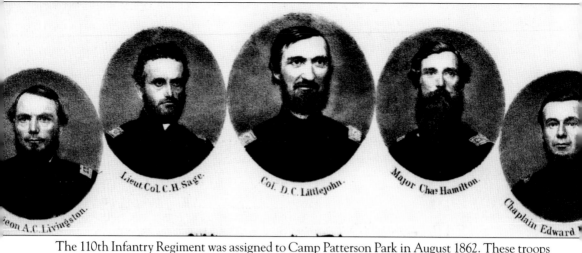

Surgeon A.C. Livingston. Lieut. Col. C.H. Sage. Col. D.C. Littlejohn. Major Chas Hamilton. Chaplain Edward

The 110th Infantry Regiment was assigned to Camp Patterson Park in August 1862. These troops had been recruited in May 1862 from Oswego County in New York State. These troops were under the command of Col. DeWitt C. Littlejohn, seen here in the middle. Later the same year, they left to fight in Louisiana.

Two

THE BUILDING OF
PATTERSON PARK

America in the mid-19th century was at a critical crossroads. The American culture and economy, which was once predominately agrarian, was changing into a mechanized, coal-consuming industrial machine. With improvement upon steam power, better iron, the harnessing of electricity, and faster means of transportation (railroads) and communication (telegraph), the United States was progressing into a new era—the Industrial Age. The Civil War was one dark shadow of this collision of cultures and of a changing economic world. After the Civil War, more and more Americans were leaving their pastoral farms to work in the industrial centers of new cities. With this influx of people came the need for proper civic planning to accommodate a rapid population increase. A key feature in this planning was the inclusion of parks or "pleasure grounds" into the new urban landscape.

American urban parks during the mid-19th century were seen as the antidote to the rapidly industrialized and urbanized cities. City parks were in direct contrast to the mechanistic world of cogs and metal and were seen as the panacea for mental, spiritual, and even physical health; that is, parks were seen as "the lungs of the city" to cleanse the city's ills and miasmic vapors. City parks became the nostalgic vestiges of a shrinking pastoral world and were the embodiment of Thomas Cole paintings and Emersonian prose.

Baltimore was no different from any other city at the time. Baltimore's population was rapidly growing, manufacturing and industry were becoming integral to its economy, and there were calls for developing a city park system to escape from the pollution and daily cacophony. In 1860, Baltimore City purchased several hundred acres from Lloyd Nicholas to create Druid Hill Park in the west and in the east purchased 29 acres to expand the boundaries of Patterson Park. After the Civil War encampments had left and Patterson Park returned to being a public park, the challenge became returning the park to its original antebellum beauty and to develop Patterson Park into a pleasure ground similar to parks in other cities such as Central Park, Fairmont Park, and Prospect Park.

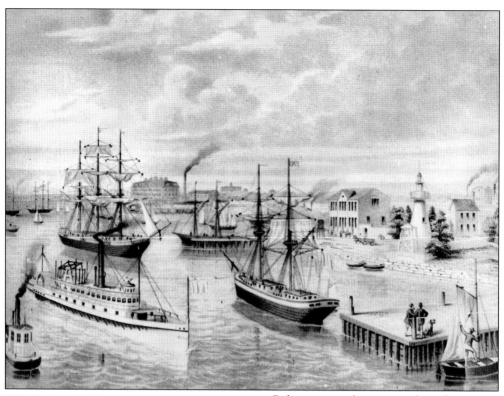

Baltimore was fortunate to have farming, manufacturing, and shipping, making it the gateway to the North, South, and even the world. Raw products could be produced on local farms or shipped from the South, then processed at Baltimore factories into finished goods to be sold at local markets or shipped up and down the East Coast or internationally. Baltimore quickly became a very important and wealthy port city. These are the Canton docks in 1860. (Courtesy of the Enoch Free Library Baltimore.)

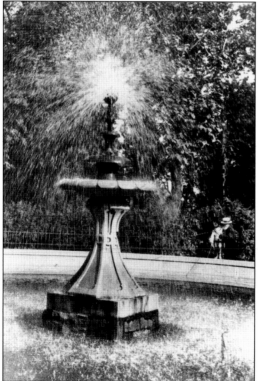

Camp Patterson Park was dismantled in 1864, and once again plans for the park began to appear as a reality. The first architectural element in Patterson Park was a marble fountain at the Lombard Street entrance built in 1865–1866. This fountain was designed by George A. Frederick, who also designed and built Baltimore's city hall (1875) and several structures in Druid Hill Park.

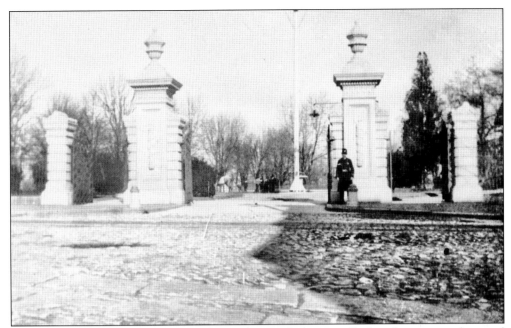

John H. B. Latrobe, a parks board member working with Augustus Faul, park superintendent, and George A. Frederick, architect, began to build park structures to draw the surrounding community into the park. These gateways at the entrance to Patterson Park at Lombard Street were designed by Frederick in 1868 and were made from marble. Iron gates were opened and closed daily by the gatekeeper, seen here *c.* 1890.

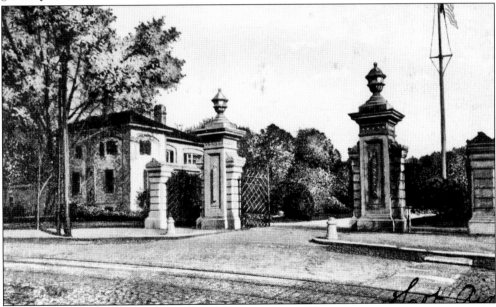

This is a postcard of the Superintendent's House and Lombard Street gates in 1900. The Superintendent's House was built in 1866 and the Lombard Street entrances in the following year. In 1866, Joshua Johnson was named the first local superintendent of Patterson Park. The house was home to Johnson and his family. The position of Patterson Park superintendent was eliminated in the 1970s. Today the house functions as the offices of the Friends of Patterson Park.

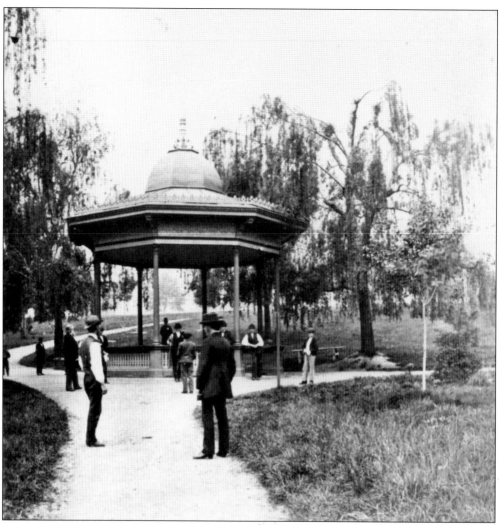

Patterson Park had a natural spring at the base of Hampstead Hill, which was sheltered under a pavilion. This Taurus Fountain, here c. 1880, had a marble bull's head where water flowed from the bull's nostrils to be captured in a tin cup for drinking. There were four such fountains in Patterson Park, some with coiled pipes running through an ice chamber keeping the water very cold.

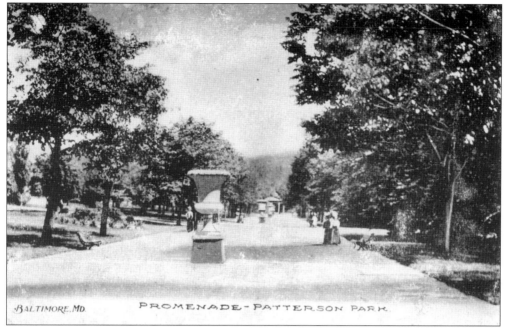

The main promenade was created as a central walk in 1874. This central promenade was lined with large native trees, while along the center of the walk, large urns were planted with decorative vines and colorful annuals. Along the path were a natural spring covered by a pavilion, picnic areas, a conservatory, and later a rain shelter built in 1893.

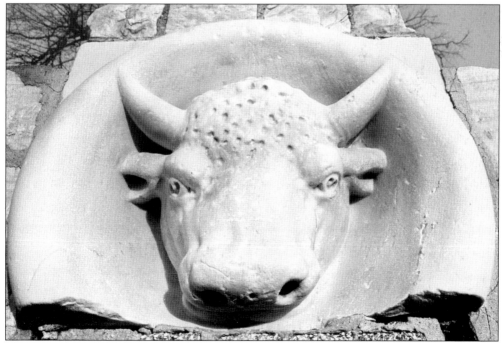

The Taurus Fountain's marble fountainhead was in the shape of a bull's head. The park's natural springs were closed down in the early 20th century due to contamination. The fountainhead was removed and built into a nearby wall. (Courtesy of Anna Santana.)

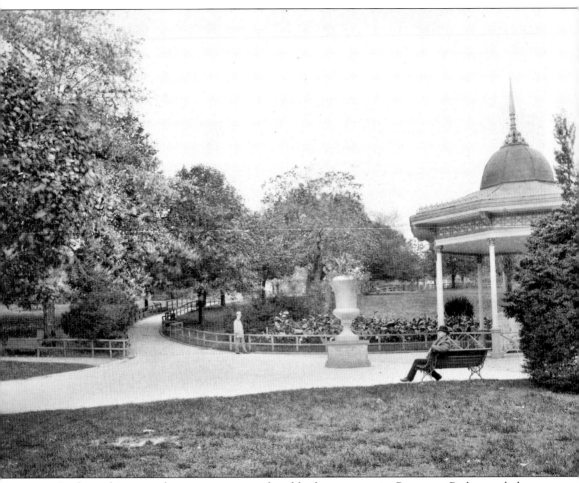

As the architects and contractors created and built structures in Patterson Park, people began to use the park more and more to enjoy the vistas, to stroll with loved ones, or simply to escape from the daily tedium and noise. The park's pathways and horticulture were designed to remove people from the streets as if they were in an Emersonian poem. The Taurus Fountain, seen here in 1899, became a popular meeting place, and benches provided a comfortable place to rest and enjoy the greenery and shade. These small park oases were scattered around the park and were designed to provide "mental refreshment." "The feeling of relief experienced by those entering them on escaping from the cramped, confined and controlling circumstances of the streets of the town; in other words, a sense of enlarged freedom is to all, at all times, the most certain and the most valuable gratification afforded by a park," according to Frederick Law Olmsted Sr. (Courtesy of the Baltimore City Commission for Historical and Architectural Preservation.)

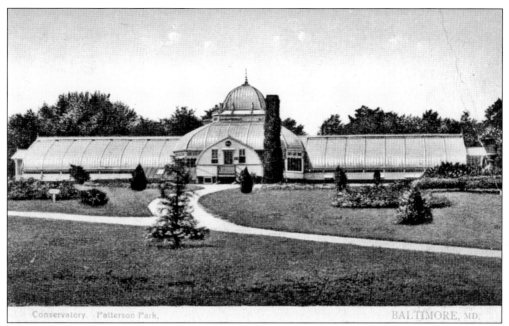

Conservatory. Patterson Park, BALTIMORE, MD.

Initially built of wood in 1876, this ornate conservatory was rebuilt with iron and glass in 1904. The Patterson Park Conservatory was lush with rare and exotic plant species from around the world. Many of these plants were donated from the National Conservatory in Washington, D.C. In 1888, plants from the Patterson Park Conservatory were used to initially stock the newly constructed Druid Hill Park Conservatory in Baltimore.

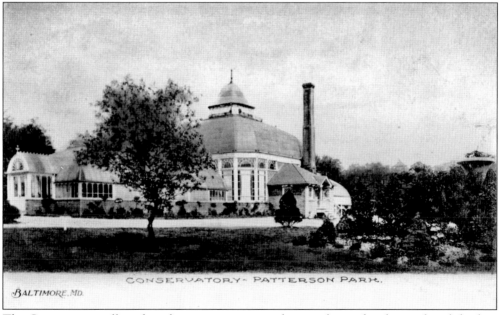

CONSERVATORY- PATTERSON PARK.

BALTIMORE, MD.

The Conservatory allowed gardeners to propagate plants to be used in horticultural displays around Patterson Park. Gardens in the park would border walkways and promenades or would be in planting beds around buildings. These beds often took on shapes and were very colorful. Common plants used were canna lilies, impatiens, coleus, and often exotic palms and cycads.

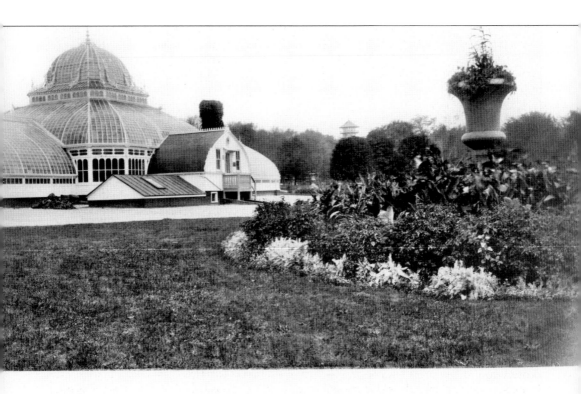

CONSERVATORY—PATTERSON PARK.

During the 19th century, exploration of exotic places provided many discoveries in natural history. Scientists traveled to foreign lands to collect new species of plants and animals and to study foreign cultures. New fauna and flora were collected in the recently annexed territories of the desert Southwest. With this came the discovery of new plants and animals and the need for exhibition space to display these exotic species to the public. Buildings that could accommodate species from desert, tropical, and Mediterranean environments were needed. Thus zoos or menageries and conservatories were built, allowing these exotic species to be safely displayed in differing climates. Conservatories such as the one in Patterson Park had large leafed tropical palms from Borneo, intricate and fragile orchids from Brazil, and large thorny barrel cactus from Arizona all under one roof but in separate rooms. (Courtesy of the Baltimore City Commission for Historical and Architectural Preservation.)

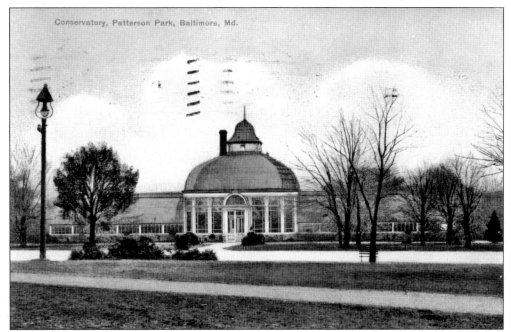

The Patterson Park Conservatory, seen here in a postcard dated 1912, was the first public conservatory in Baltimore. Other Baltimore conservatories included the Clifton Park Conservatory (the conservatory of Johns Hopkins, himself an avid horticulturalist), the Carroll Park Conservatory, and the Druid Hill Park Conservatory, the only remaining conservatory in Baltimore. The Patterson Park Conservatory fell into disrepair and became dangerous. It was razed in 1948.

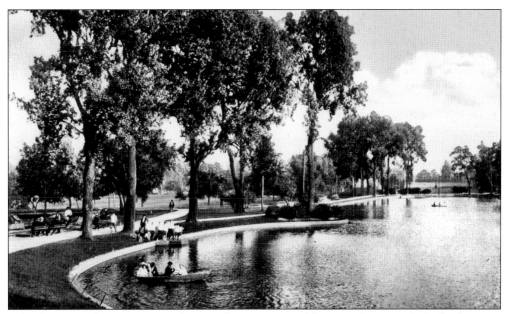

What began as a drainage issue in the 1860s became a central feature to Patterson Park's landscape—the Boat Lake. In the early 1900s, small rowboats could be rented and paddled around the lake, and during the winter many skated on the lake. This 1910 postcard is of the Boat Lake.

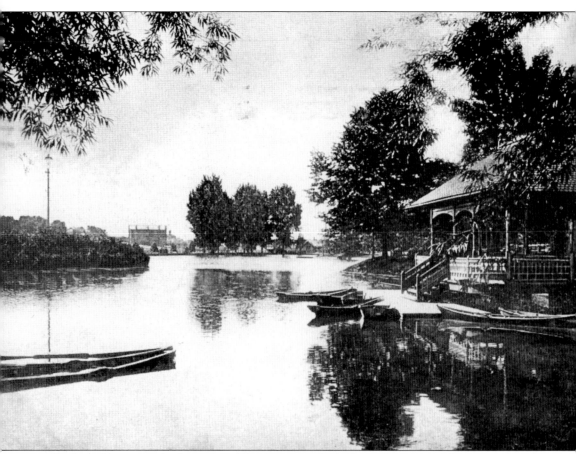

The Boat House was built in 1887. The Patterson Park Boat House is similar to many park structures of the time as seen in Central Park in New York, Prospect Park in Brooklyn, and Fairmont Park in Philadelphia. In 2002, Baltimore City Department of Recreation and Parks renovated the Boat Lake. Today the Boat Lake is home to egrets, herons, painted turtles, and a neighborhood fishing rodeo.

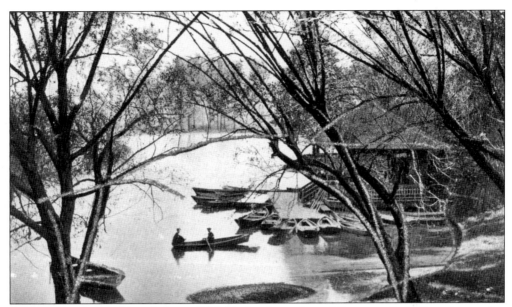

This picture is of the Boat Lake in 1904. Under the surface of Patterson Park, there is complex hydrological system of water flow. Much of this feeds the Boat Lake. At one time, there was a stream that came through Patterson Park—Harris Creek. When the first settlers came to the area in 1667, they were able to sail into what is now Patterson Park.

Lakes and ponds were central features to many urban parks in the 19th century. They provided habitat for species of birds and fish and were often surrounded by trees. Most lakes were man-made and were designed to have still water so as to offer a reflective appearance with a calming effect.

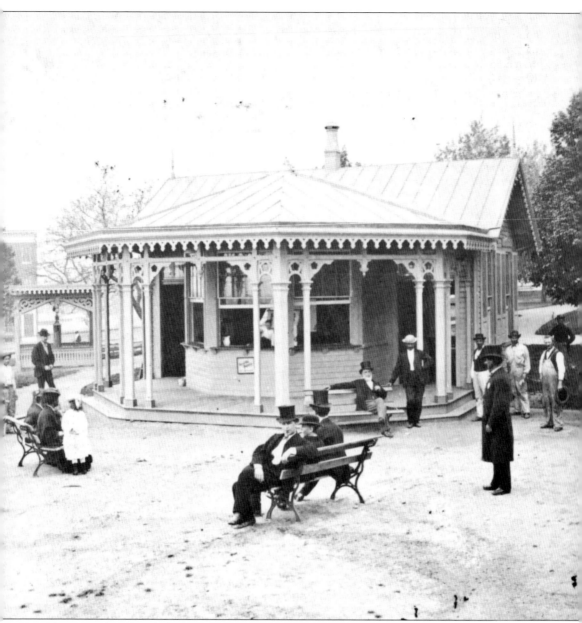

This gingerbread-style building was erected in 1870 and served as a refreshment stand selling beverages, ice cream, and confectionary. It was called the Little Casino. Such stylized buildings with ornate eaves and columns were made possible by the Industrial Age. Better and stronger woodworking tools made it easier for craftsmen to create these designs. In the early 1890s, Charles Latrobe, the superintendent for parks, had the Little Casino picked up and moved across the path from Rodger's Bastion on Hampstead Hill to make way for the construction of an observatory in 1891. Sadly the Little Casino no longer exists.

In 1873, the Baltimore Parks Commission annexed more land, and Patterson Park increased to 56 acres. The park had dramatically improved in a matter of 10 years from an empty landscape to a fashionable pleasure ground adorned with gardens and fountains, a conservatory, several ornate entrances, a boat lake, a refreshment stand, a historic landmark to the War of 1812, and a few miles of curvilinear carriage paths and walkways. This is a map of Patterson Park in 1881.

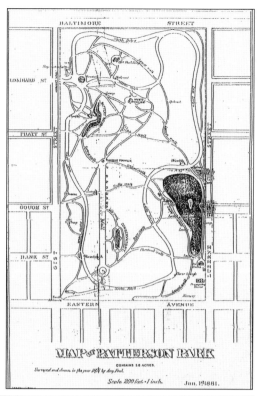

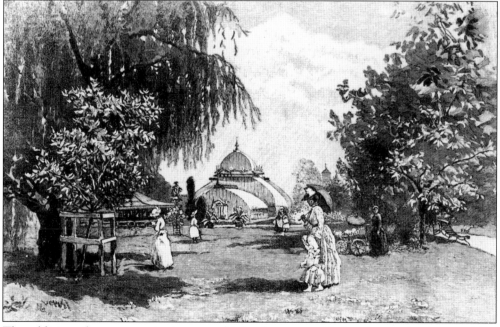

The addition of conservatories into a park's landscape provided an interesting juxtaposition between glass, metal, and the organic world and also between the natural world of native outdoor plants and trees and the "artificial" exotic world under the conservatory's glass. This lithograph is from the 1899 Public Park report.

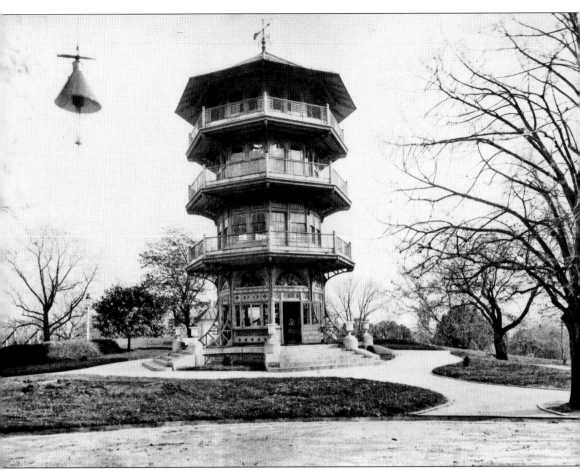

Charles H. Latrobe built this park observatory in 1891. Due to its Asian motif, the Patterson Park Observatory became known as "The Pagoda." Such exotic motifs were in vogue during the Gilded Age. Standing 60 feet tall on a high promontory, the view from the Pagoda extends for miles and offers beautiful vistas. The Pagoda stands on Hampstead Hill, a high promontory and key battlement during the Battle for Baltimore in September 1814. The Observatory or Pagoda was built of iron, glass, and wood. The main structure is of iron while the decks and facade are wood. Spiraling up through the middle of the tower is a staircase, and stained-glass windows are at each entrance. (Courtesy of the Baltimore City Commission for Historical and Architectural Preservation.)

This is the original drawing of the Patterson Park Observatory (the Pagoda), dated 1891 and signed by Charles H. Latrobe. Cornelius Sheehan, a local contractor, began building in June 1891 and took six months to complete the Asian-styled observatory. The total cost was $16,730. Sheehan's next Patterson Park project was the Casino, built in 1892–1893. (Courtesy of the Friends of Maryland Olmsted Parks and Landscapes.)

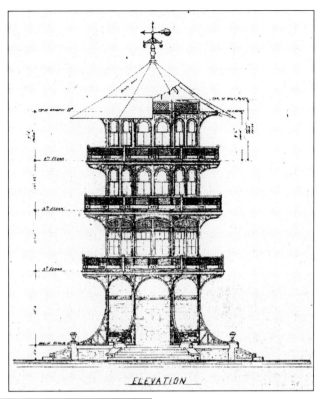

ELEVATION

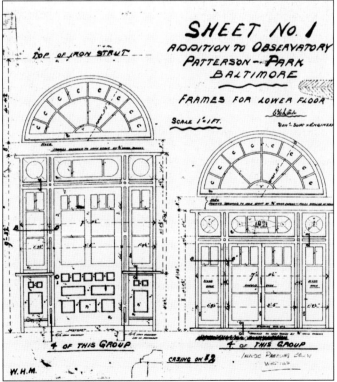

Charles H. Latrobe (1834–1902), the architect of the Pagoda, was the grandson of Benjamin Latrobe Sr., the architect of the U.S. Capitol, which was destroyed by the British in August 1814. Charles Latrobe was born in Baltimore. He attended St. Mary's College in Baltimore and studied engineering. Later he applied his knowledge working for the B&O Railroad building bridges. In the 1880s, Charles Latrobe was asked to serve as the superintendent of parks. Here is an original shop drawing of the Pagoda's doors, showing the pattern for the stained glass. (Courtesy of the Friends of Maryland Olmsted Parks and Landscapes.)

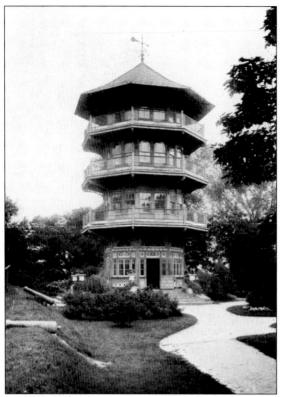

The Latrobe family was very influential in the development of Baltimore's parks and architecture. Benjamin Latrobe Sr. was the architect for the Baltimore Basilica (1806), Benjamin Latrobe Jr. was a building engineer for the B&O Railroad, John H. B. Latrobe was instrumental in Baltimore's parks system, Charles Latrobe was superintendent of Baltimore parks, and Ferdinand Latrobe was a six-term mayor of Baltimore in the mid- to late 1800s.

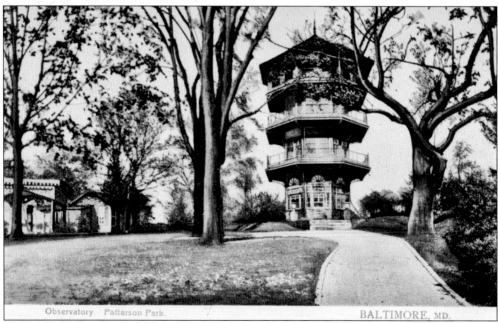

Observatory. Patterson Park. BALTIMORE, MD.

During the Gilded Age (mid-19th century), travels to exotic lands in the Islamic world and in Asian countries brought back to the United States new motifs that were used by architects for many new park buildings. Islamic domes and archways were design elements in many park trolley stops and concert pavilions, and Asian designs were used to accent the Patterson Park Observatory.

Patterson Park began as a gift to the City of Baltimore from William Patterson in 1827. This initial six-acre "Public Walk" grew into the present 137 acres. In its development, Patterson Park has been graced by two distinct types of parks within its boundaries, that is, the older more pastoral park reminiscent of Olmstedian ideals and the modern, utilitarian recreational park. This original map shows Patterson Park in 1890.

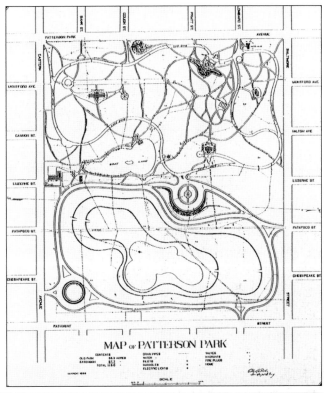

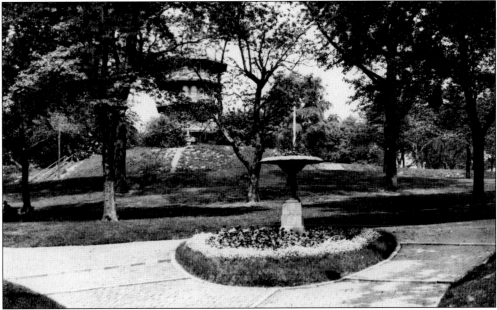

In 1887, Charles Latrobe had 10 electrical lights installed in Patterson Park. They were switched on as needed and never were kept on after midnight. Patterson Park was one of the first parks in Baltimore to use an early electrical lighting system, the arc lamp. The arc lamp was a system using high-voltage electricity and two pieces of carbon inside a glass lamp. This is the garden near the Pagoda in 1900.

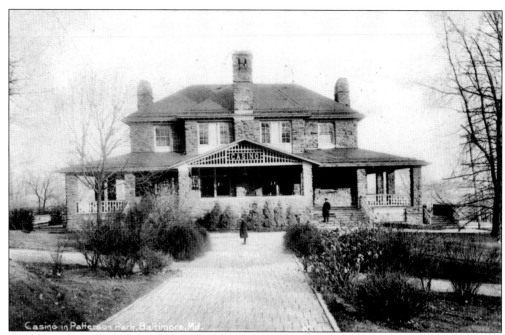

The term "casino" originally meant a small Italian villa or summerhouse. In public parks during the Gilded Age, a casino was a clubhouse or a building used for social meetings, dances, or other public amusement. Charles H. Latrobe had the Patterson Park Casino built in 1893, and it served as the center of these same activities. This is a picture of the Casino in 1902.

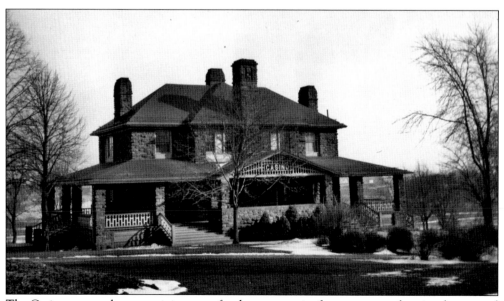

The Casino was used as an activity space for the community for many years, hosting dances and games, but it also served as park headquarters and at one time was an apartment for the deputy superintendent for Patterson Park. In the early 1970s, the Casino was set afire by vandals but was restored a few years later.

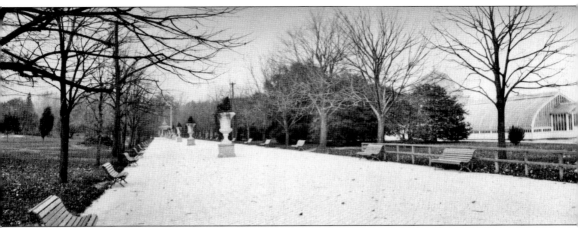

In the 19th century, a new discipline was created to meet the challenge of designing and building urban parks and pleasure grounds. New urban landscape architects were tasked with creating common public green spaces in and amongst the bricks and concrete of the city. Frederick Law Olmsted Sr. was such a thinker and architect, designing such great parks as Central Park and Prospect Park and park systems like those in Louisville, Kentucky, and Buffalo, New York. Andrew Jackson Downing was a major influence on urban park design, and his writings and drawings in *A Treatise on the Theory and Practice of Landscape Gardening* inspired many park structures and buildings. In Baltimore, renaissance thinkers and philanthropists like John H. B. Latrobe created a vision for Baltimore's park system, and it was Howard Daniels and George Frederick who influenced their design and construction. (Courtesy of the Baltimore City Commission for Historical and Architectural Preservation.)

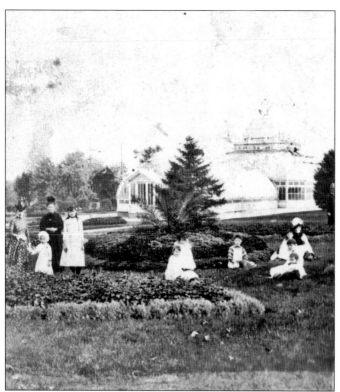

Many of the new residents of industrialized cities had left the green rolling hills of farms and prairies. Parks became a comfortable respite and a glimpse into a simpler world. The conflict of the natural world and that of the mechanical Industrial Age is referred to in many stories and novels by Nathaniel Hawthorne, Ralph Waldo Emerson, and Henry David Thoreau. Such prose spoke to the need for inner peace through environmental beauty. Children are shown in front of the Conservatory c. 1890.

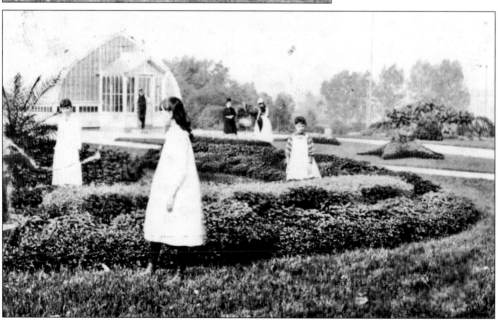

Artists like Thomas Cole (American Hudson River School, 1801–1848) painted rich canvases depicting folkloric scenes in deep green Hudsonian forests, while landscape architects strove to re-create those same scenes in Brooklyn, Manhattan, Boston, Philadelphia, and Baltimore. Parks provided this illusion in the inner cities, which became even more important after the carnage of the Civil War. This stereoview of the Conservatory dates to c. 1890.

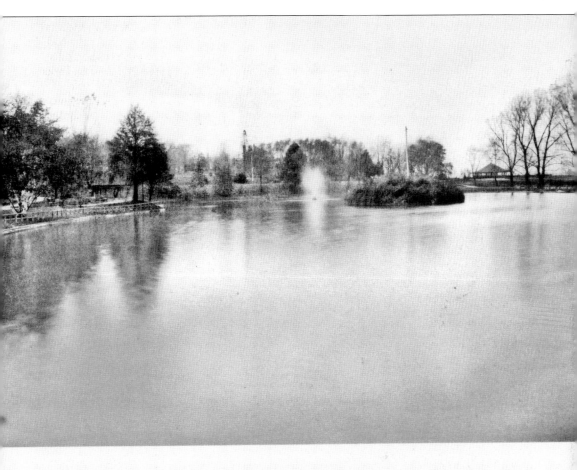

LAKE IN PATTERSON PARK.

From 1866 to 1886, Patterson Park often competed with Druid Hill Park for amenities and activities. Since Druid Hill Park was home to a zoo, Patterson Park needed to follow suit. Deer freely roamed Patterson Park in the 1860s, and from 1877 to 1886, there were monkeys that delighted children in the park. In the 1880s, park management built a little zoo with alligators, ibises, foxes, Egyptian geese, pea-fowl, cockatoos, and a even few eagles. According to the park's bureau reports, 13 sheep roamed the park to keep the grass low and well maintained. (Courtesy of the Baltimore City Commission for Historical and Architectural Preservation.)

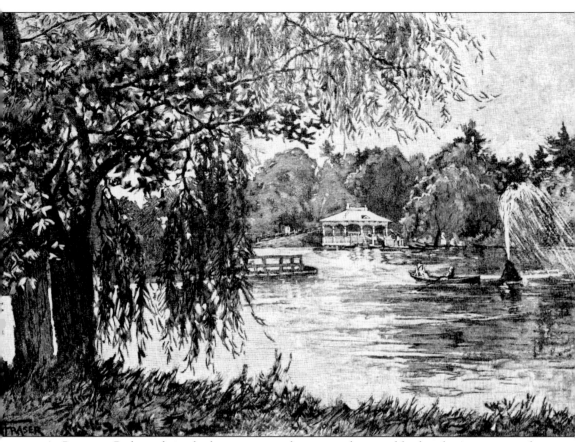

As Patterson Park was being built, so too were the surrounding neighborhoods. As more people came to Baltimore to work and live, more houses were being built. New city dwellers preferred to live near Patterson Park, and so new communities were developing right across from the park. Several neighborhoods surround Patterson Park: Canton, Fell's Point, Butchers Hill, and Highlandtown. The Canton neighborhood is south of the park and was developed from the plantation of merchant seaman John O'Donnell in the late 1800s by his son, Columbus O'Donnell, William Patterson, and Peter Cooper. Canton's waterfront was used for shipping, shipbuilding, and later industry. The first branch of the Enoch Pratt Free Library, built in 1886, is located in Canton on O'Donnell Square. This lithograph of the Boat Lake is from the 1899 Public Park report.

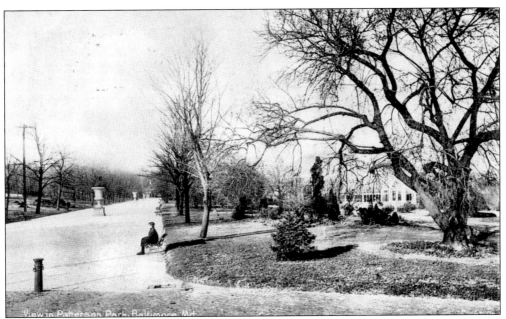

To the west of Patterson Park is Fell's Point, founded in 1730 by William Fell. Fell's Point became a shipbuilding and commercial center. During the War of 1812, Fells Point built the fast-moving clipper ships and supported privateers who harassed the British fleet. Fell's Point became a major center of immigration, adding to Baltimore's labor force and ethnic diversity. This view is of the central promenade with the Conservatory in the background c. 1890.

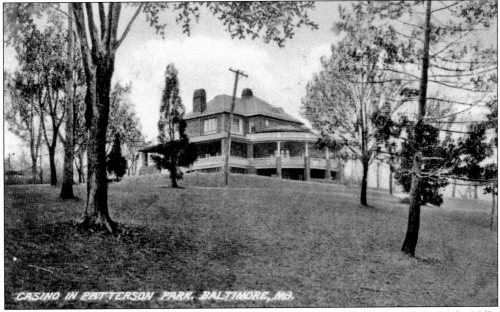

To the east of Patterson Park is Highlandtown (established in 1866). Once called "Snake Hill," the community was settled by German immigrants. During the Civil War, the area was home to Fort Marshall, a Union encampment, and in 1870, residents renamed the neighborhood Highland Town because of its elevated view of the city. In 1919, the neighborhood was made part of Baltimore City. Here is a view of the Patterson Park Casino in the early 20th century.

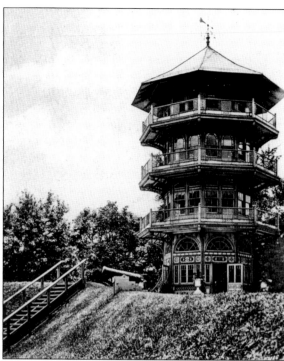

To the northwest of the park and near the Pagoda is Butchers Hill, a community aptly named for the butchers who worked in the area during the mid-19th century. Then this area was on the outskirts but was close to livestock, farms, and markets. During the Civil War, butchers became very prosperous by selling their meat to the Union encampment. One such butcher was Jacob J. Bankard, who amassed a fortune and built himself a stately mansion in the neighborhood.

PATTERSON PARK PAY ROLL.

WM. J. C. DULANY & CO., CITY STATIONERS AND PRINTERS.

1882 February 9th	No.	WORKMEN'S NAMES.	ending Thurs Feb 9 Friday Saturday Monday Tuesday Wednesday Thursday	DAY'S WORK.	WAGES.	AMOUNTS. Dolls. Cts.	RECEIPTS.
		Wm Fraser	2 weeks at 23. 07 per week			46 14	Wm Fraser
		Nelar Barton	2 " " 8 " "			16	S Barton
		James Smith	2 " " 10.50 "			21	James Smith
		John W Jones	12½ days		175	21 87	J W Jones
		Wm D Hamilton	13 "		150	19 50	Wm D Hamilton
		George Talbot	12½ "		"	18 75	George Talbot
		George Trice	12½ "		"	18 75	Geo. Trice
		Owen Boylan	12½ "		"	18 75	Owen Boylan
		Michael Boylan	13½ "		75	10 12	Michael Boylan
		Michael Hingh...	2 "		150	3	Michael ... per Ame Smith
		Rudolph Kestner	2 "		"	3	Rut Fistner
		Patrick Burke	2 "		"	3	Patk & Bourk per M. B.
		Wm Kirby	1¾ "		"	2 62	Wm Kirby per John Smith
		John Smith	1¾ "		"	2 62	John Smith
						$205 12	

Here is a Patterson Park payroll sheet from February 9, 1882. During the mid-19th century, immigrants came to Baltimore from Ireland and Germany and made their new home. Many worked in the new park system. William Fraser made $46.14 for two weeks' work. Maintenance buildings with a functioning ironwork shop were built in 1878. In 1892, the yearly expense for park "horse-shoeing" was $12.

Observatory Patterson Park. Baltimore, Md.

The first series of concerts in Patterson Park was in the summer of 1888. These concerts were quickly cancelled by the park's superintendent due to his belief that musical concerts after dark encouraged immorality. It would appear that the couples could get together despite the 10 electrical arc lamps installed 1887.

OFFICE OF THE COMMISSION OF PUBLIC PARKS,
CITY HALL.

No. 323

Baltimore, August 14th 1883

City Comptroller, Pay to Rob't J Halliday or Order,

Twenty eight 82/100 Dollars,

out of the appropriation for

D. H. Park 24.12 Patterson Park 4.70

as per bills annexed

D. Rany luce Sec'y and Treas.

$28.82/100

Wm. J. C. Dulany & Co., City Printers & Stationers.

This is an 1883 payment check for the reimbursement of seeds and horticultural needs for Druid Hill ($24.12) and Patterson Park ($4.70) from the Office of the Commission of Public Parks.

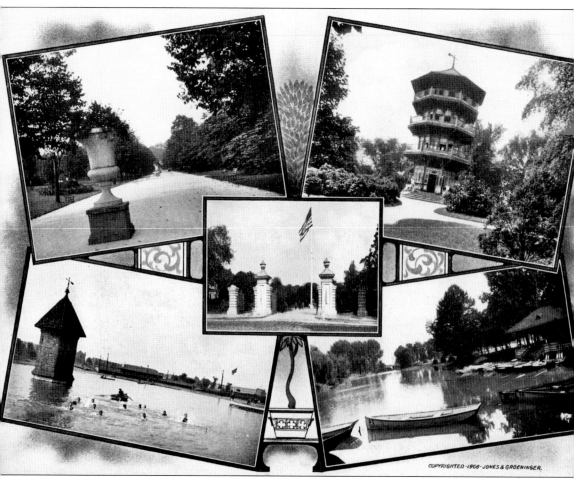

COPYRIGHTED -1906- JONES & GROENINGER.

Here is a montage of Patterson Park's attractions from a Baltimore trade journal in 1910. The development of parks in the 19th century served many purposes in the new urban industrial environment. Public green spaces, such as Baltimore's Patterson Park, provided daily respites from the fast-paced city living, acted as the "lungs of the city" cleaning the air and water, created attractions for the new neighborhoods, and enticed the building of new homes, buildings, and communities.

Three

RECREATIONAL MOVEMENT

In the late 19th century, American society was facing new opportunities and unique challenges related to industrialization and the development of urban centers. During this era, the American middle class grew, newly arrived immigrants helped to build ever-growing inner-city communities, and calls for reform filled the air. Jacob Riis's photographs of "the other side of the tracks," however, showed that not everyone shared the newfound successes and wealth. Many people working in these industrial centers were living without basic needs, poverty and overcrowding was rampant, and many children were forced to work in unsafe conditions. Although cities prospered, crime was on the increase and civility was on a decrease.

Municipal and civic leaders during the Progressive Era (1890–1920) recognized the challenges of urban living and sought to improve the quality of life by actively using parks to solve these problems. Parks became integrated into the planning of communities, especially lower-income, working-class tenements. The priority for parks became physical exercise, organized play, health, and public hygiene. Playgrounds, ball fields, and public baths were created, focusing on the rules of play and proper civil behavior. Previously parks were seen as refuges from daily life, places of imagination, and distractions in sharp contrast from urban life. At the beginning of the 20th century, parks were used as a tool to deal with crime, health, and civility.

In Baltimore, it was prominent civic leaders and private associations who came together to form the Children's Playground Association (CPA) and the Public Athletic League (PAL) with the mission of providing safe and supervised active recreation to the public. As a result, new playgrounds were constructed, public baths were better maintained, and athletic leagues were organized.

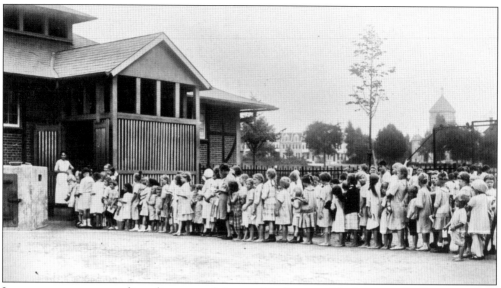

In response to overcrowding, disease, and the need for better public hygiene, the Patterson Park pool and bathhouse, seen here in 1909, were erected in 1905 to provide public baths, since many local residents did not have access to such amenities at home. Patterson Park was a pioneer for such facilities for public health and hygiene.

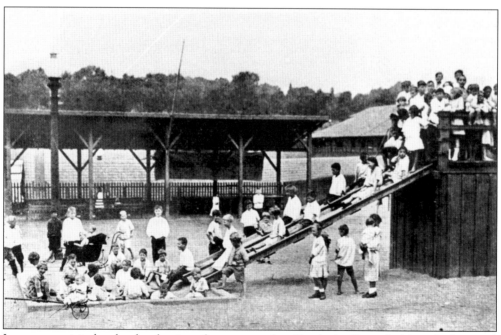

In many municipal parks, the planting of trees was replaced by the building of athletic facilities and playgrounds. This change in focus was apparent in a 1899 report from the Park Commissioners: "There has been for some time an earnest desire expressed by many of our citizens that the Board should give a decided encouragement to the welfare of young people by providing athletic fields in some of the parks." The Patterson Park playground appears here *c.* 1908.

On the cusp of the 20th century, the Progressive Era sought to instill new ideals in American society. Many of these ideals focused on principles of health, hygiene, and the development of improved character. Parks served as a crucial landscape for the implementation of these ideals, and in 1897, the Children's Playground Association (CPA), founded by Eliza Ridgely and Eleanor Freeland, began to advocate for more playgrounds and recreational facilities in urban environments like Baltimore. This association also believed in supervised play, which would teach children not only proper athletic form but also instill manners and moral integrity. These teachers were exclusively women. Playgrounds, like this one in Patterson Park, c. 1910, were paid for by the CPA. Such efforts were supported by private donors and municipal funds.

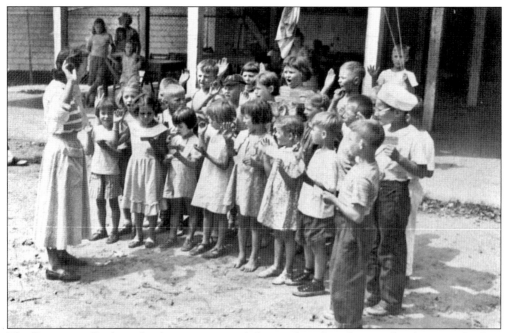

The Progressive Era brought about many social changes based on the agenda of improved safety, education, and health. During this time period, the reform movements were for temperance (18th Amendment), educational reform (Americanization), suffrage (19th Amendment), and anti-trust laws. The children here are seen taking a playground safety oath c. 1910.

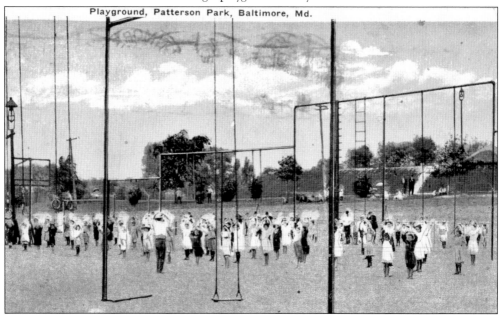

In 1900, the Baltimore City Parks Board endorsed the newly formed Public Park Athletic Association, the precursor to the Public Athletic League (PAL). Its founder was the wealthy Robert Garrett, son of John W. Garrett, B&O Railroad president. Robert Garrett was the 1896 Olympic gold medalist in the discus and remained involved in youth sports until 1950. The Patterson Park open-air gymnasium, seen here, was built in 1904.

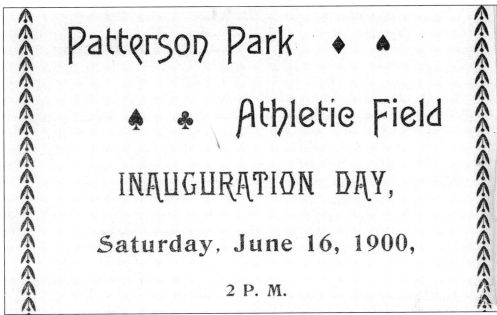

On June 16, 1900, the athletic fields in Patterson Park were officially opened to the public. This is the official program from the event. The superintendent of Patterson Park described the new park landscape: "An athletic field, almost perfect in every detail, has been laid out. A quarter-of-a-mile cinder track encircles the baseball and football field. One additional football field has been added. An athletic dressing-house has been placed upon the grounds, containing sanitary closets, baths, and toilets." (Courtesy of the Enoch Pratt Free Library, Baltimore.)

MUSICAL PROGRAMME.

MARCH	"Monumental City"	Steinwald
OVERTURE	"Zampa"	Herold
SELECTION	"America"	Bendix
"A TRIP TO CONEY ISLAND"—Serio-Comic Fantasia—		Tobani

SYNOPSIS—All Aboard—Life on the Ocean Wave—Italian Band—Appearance of Jubilee Singers—All Ashore—Carousel—Passing a Free and Easy—Ejecting an Unpleasant Customer—The Little German Band—At West Brighton Hotel—Thunder Storm—Seidle's Orchestra, Lohengrin—To Manhattan Beach—Sousa's Band—Paine's Fireworks—Home Sweet Home.

CAKE WALK	"A Warm Reception"	Anthony
SELECTION	"Faust"	Gounod
SPANISH SERENADE	"La Paloma"	Yendier
WALTZ	"The Skaters"	Waldteufel
SELECTION	"Every Day Songs"	Steinwald
MARCH	"Mr. Thomas Cat"	Hall
AMERICAN PATROL	- - -	Meacham
	"Star Spangled Banner"	

Prof. O. P. STEINWALD'S MILITARY BAND.

Field and Track Officials.

P. E. Murphy	Manager	St. Elizabeths
John H. Blacklock	Asst. Managers	Unattached
P. T. O'Malley		St. Elizabeths
H. G. Penniman	Referee	M. A. C.
P. T. O'Malley	Clerk of Course	St. Elizabeth
John Baer	Assistants " "	M. A. C.
Henry Iddins		
John H. Blacklock	Chief Inspector	Unattached
Jas. F. O'Malley	Assistant "	St. Elizabeths
Jas. Smith		
Jas. Swain	Field Judges	D. A. C.
F. P. Knight		D. O. C.
Henry Wilkins		M. A. C.
Chas. Seybold	Track Judges	
Jas. Henry		C. B. L. Institute
Jas. A. Kavanagh	Announcer	St. Elizabeths
Paul Mason		Peabody Outing
Charles Diffenderfer	Timers	D. A. C.
E. R. Angerman		City College
John Murphy		D. A. C.
John Thornton	Measurers	St. Elizabeths
John Flynn		
Nevison Long	Starter	M. A. C.

"I NEVER DISAPPOINT"

CHAS. RUZICKA

THE MODEL PRINTERY

Fair Charges		GAY AND
No Delays		FORREST
Superior Work		STREETS.

This is the program of events for opening day of the athletic fields in 1900. The first march was "The Monumental City," a nickname given to Baltimore due to all the monuments throughout the city. The "Star Spangled Banner" was also on the program. Though not officially made the American national anthem until 1931, it was often played before the raising of the American flag, especially in Baltimore. (Courtesy of the Enoch Pratt Free Library, Baltimore.)

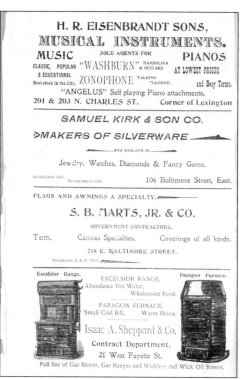

Like modern sporting events, the 1900 opening of the Patterson Park athletic fields also had local business sponsors: a furnace and stove distributor, a jeweler, a contractor, and a musical instrument maker. The Eisenbrandt family still works in the area, not as instrument makers but in the field of historical restoration. (Courtesy of the Enoch Pratt Free Library, Baltimore.)

In the later 1800s, Patterson Park was increased to 112 acres. The plans for this newly acquired land was different than in the past. Where once such land was designed to provide a pleasure ground of gardens and benches, this new era of reform parks saw the land better used as an active arena with facilities to move people's minds and bodies. Reclamation began in 1883 and did not finish until 1913.

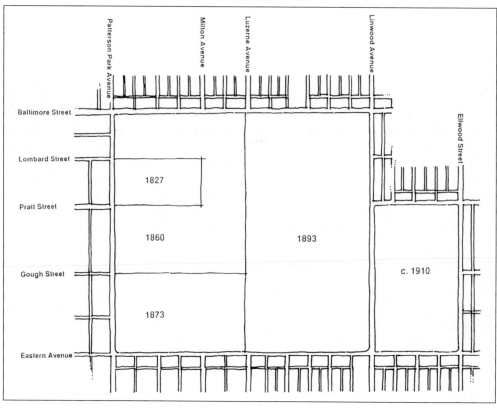

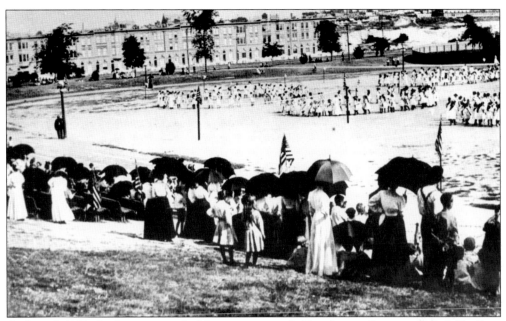

On June 2, 1902, the first municipal athletic games were held at the new Patterson Park fields. Over 15,000 were in attendance. The Public Athletic League began to directly supervise and manage recreational programming in public parks. By 1908, the Children's Playground Association had opened and was now managing over 28 playgrounds in parks or school yards, many in working-class neighborhoods.

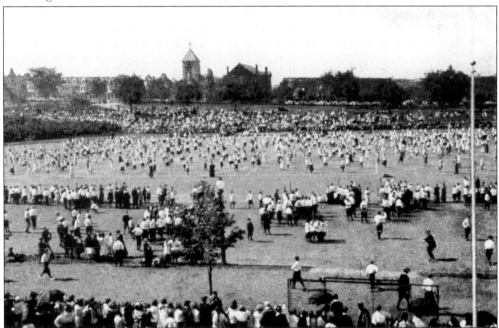

Patterson Park had one of the larger track and field areas in Baltimore, and many city track meets occurred in the park. Not only would students enjoy the park on the day of the meets, but also neighbors would come into the park to watch the athletic event. Here is picture of a track and field event c. 1920.

The 1893 World's Fair in Chicago inspired the City Beautiful Movement. This movement proposed a systematic approach to urban planning with the belief that good planning can be both efficient and beautiful and can produce economic benefits to urban growth. In Baltimore, the Municipal Art Society espoused these ideals, and in 1902, they hired Frederick Law Olmsted Jr. and his brother, John Charles Olmsted, to develop a comprehensive plan for Baltimore's parks and landscapes. In 1904, Frederick Law Olmsted Jr. (1870–1957), seen here, personally hand delivered the brothers' report, entitled "The Development of Public Grounds for Greater Baltimore." This report described Olmsted Brothers' vision of creating an "Emerald Necklace" around Baltimore by connecting the larger parks via parkways and stream valleys. Their father had created a similar system in Boston. In Baltimore, this vision called for the planned integration of natural landscapes among the bricks and steel, while providing everyone equal and easy access to parks citywide. Unfortunately, due to the lack of city funds and the speed at which the city was growing, many facets of the Olmsted Brothers plans were never implemented. (Courtesy of the Friends of Maryland Olmsted Parks and Landscapes.)

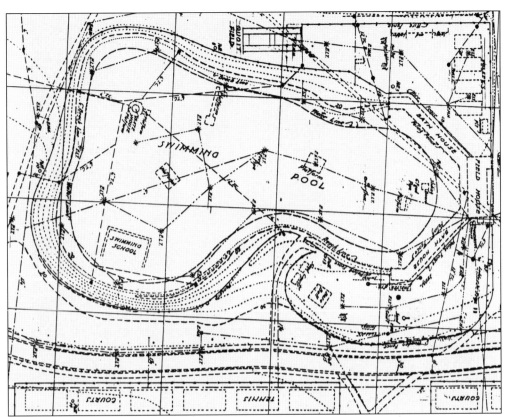

For Patterson Park, the 1904 Olmsted plan called for the purchase of land from the Canton Company and the extending of park property several blocks eastward. This would have nearly doubled the size of the park to well over 200 acres. The parks commission did not have sufficient funds for the originally proposed 100-plus acres but in 1908 purchased 20 acres. These are the 1915 Olmsted Brothers plans, which also included a detailed design for the "Extension" to the east. (Courtesy of the Friends of Maryland Olmsted Parks and Landscapes.)

Between 1905 and 1915, the Olmsted brothers were hired to design the easternmost areas of Patterson Park, which were being used primarily for recreation. The task was to integrate the athletic fields and playground into their civic landscape plan. The final Olmsted designs (seen in these original drawings) were used to create a recreational complex comprised of a swimming pool, playground, outdoor gymnasium, and field house tied together by a series of walkways and paths. (Courtesy of the Friends of Maryland Olmsted Parks and Landscapes.)

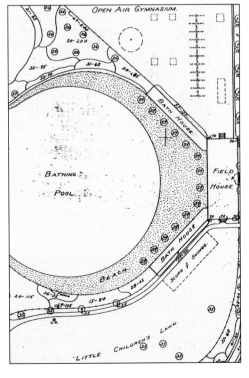

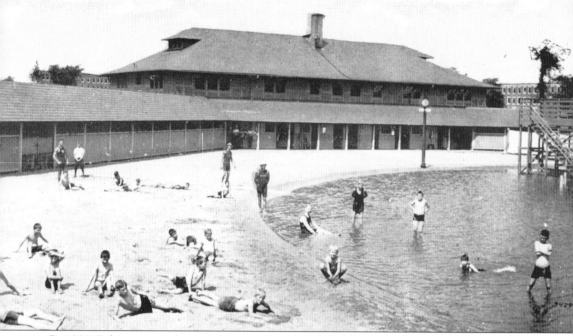

By 1900, Baltimore was the sixth largest city in the United States (with a population of 509,000). Urban overcrowding had made it necessary to promote public hygiene and cleanliness during this era, and to this end, parks became home to "public baths" and pools. This was part of a wider trend toward public health reform. Cleanliness also became associated with the middle-class, self-respect, and good character. These "Bath Reformers" believed that such facilities would help to Americanize newly arrived immigrants from Eastern Europe, and many of the baths and pools were located near such populations. Patterson Park's bathhouse is an example of this movement. This building housed baths, changing rooms, and a pool. The showers had both hot and cold running water. Here is a postcard of the pool and bathhouse *c.* 1912.

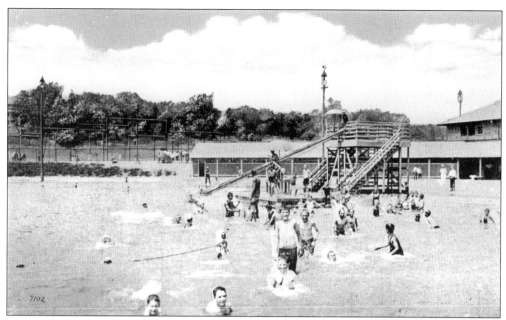

The bathhouse and pool area was built in 1905 and designed by Wyatt and Nolting of Baltimore, modeled after the Olmsted brothers' plans. The building had a Tudor-style design and was made of concrete and wood. This bathhouse had two diagonal wings that housed changing rooms and baths for the pool. One wing was for males and the other for females. The swimming pool is shown here in 1915.

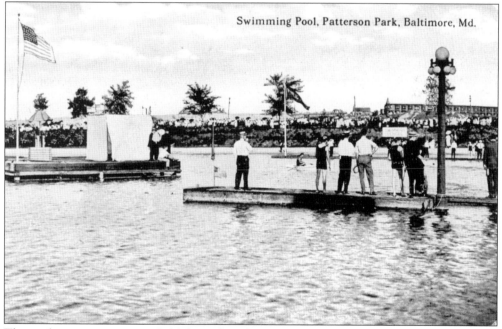

The pool was a two-acre graded lake with a clay bottom. Every spring, new sand was brought to the pool to create a beach, and water was added to the pool from the Boat Lake up the hill through a series of pipes. The management of the pool was in the hands of the Free Public Bath Commission until 1918. This postcard of a swimming competition is dated 1917.

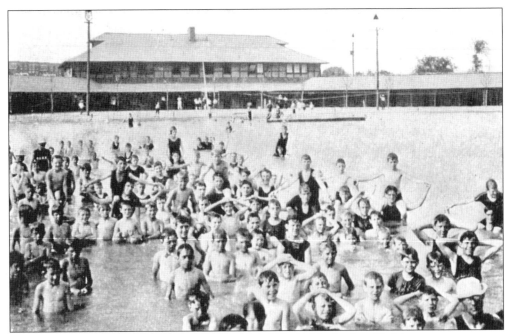

The Free Public Bath Commission noted in 1914: "The Public Baths of Baltimore represent one of the chief agencies in the City for the promotion of health and cleanliness. The system provides for cleansing baths, which are open all year round in congested City districts, and recreative swimming pools, open during the summer. The one at Patterson Park has the largest artificial swimming pool in the United States. The annual cost to the City for maintenance of the entire Public Bath System is about $40,000."

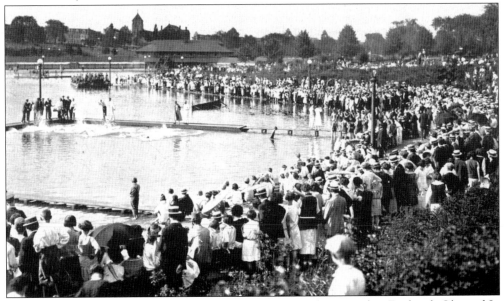

In 1906, Mr. Baedenkoff, supervisor of Patterson Park's pool, reported to Frederick Olmsted Jr. that the bathing pool had been so popular it would have to be considerably enlarged; in 1908, the pool was re-graded and enlarged to accommodate more swimmers. This swimming competition occurred in Patterson Park *c.* 1910.

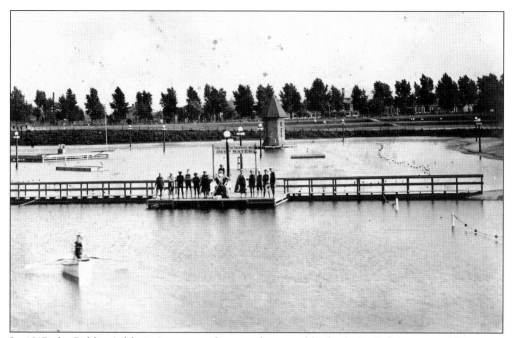

In 1917, the Public Athletic League took control over public baths in Baltimore, and Patterson Park's pool became the site of many local swim meets. Pools became very important to the surrounding neighborhoods, providing recreation and a place to cool down during Baltimore's humid summers. The Patterson Park swimming pool is pictured here in 1909.

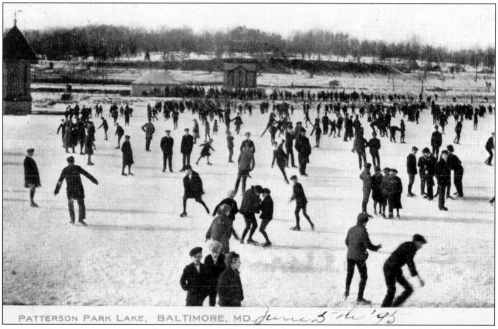

During the winter months, the pool was allowed to freeze over, and many took advantage of this by skating atop the ice. The Boat Lake was also used for skating and even had a small shelter for skaters to warm up and to put on their skates. This 1911 postcard shows skaters in Patterson Park.

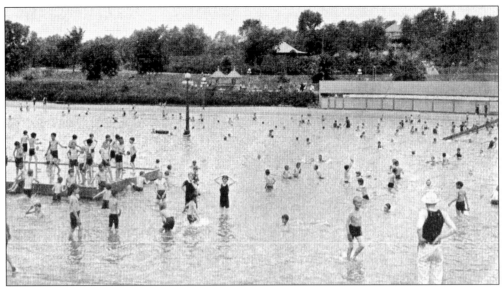

In 1896, the Supreme Court decision of *Plessy v. Ferguson* permitted states to prohibit blacks from using "public accommodations" if also used by whites. These Jim Crow–era laws had a devastating effect on Baltimore's African American population and their use of public parks. In 1904, Maryland passed similar Jim Crow legislation, permitting segregation on many forms of transportation. Though never legislated, Baltimore parks were managed under the concept of "separate but equal," and many common public park facilities were either closed to African Americans or alternative separate facilities were built. Pools, picnic pavilions, playgrounds, and tennis courts were examples of such facilities.

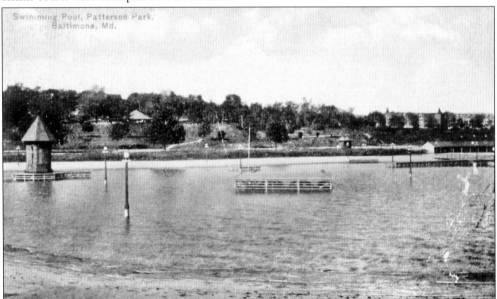

In 1947, Dr. Bernard Harris was the first African American appointed to Baltimore's Parks Board. He was frequently the sole vote against segregationist policies in public parks. In 1949, Robert Garrett, founder of the Public Athletic League, was removed from the Parks Board due to his segregationist views. Several protests in Baltimore parks slowly began to erode these harmful policies, and on June 23, 1956, Baltimore's public swimming pools became fully integrated.

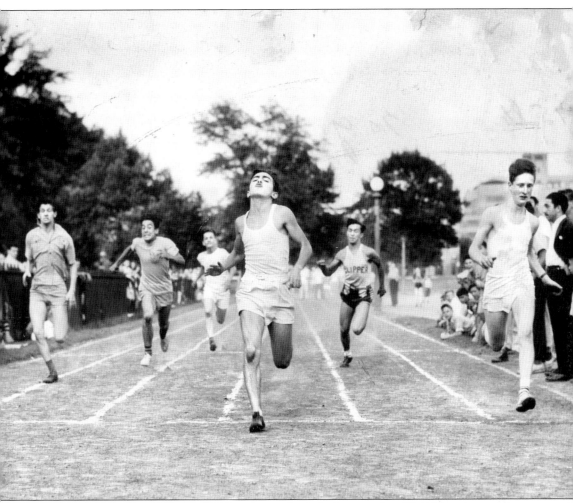

The Jewish Educational Alliance (JEA) was created to help the more than 50,000 Jewish immigrants that came to Baltimore in the early 1900s. The first JEA building opened in 1913 at 1216 East Baltimore Street, not far from Patterson Park. The JEA taught classes in citizenship and provided day camps, religious schooling, and other educational opportunities. The JEA sponsored several athletic teams and many clubs. The JEA track team competed in Patterson Park at many track meets. (Courtesy of the Jewish Museum of Maryland, 1992.231.150.)

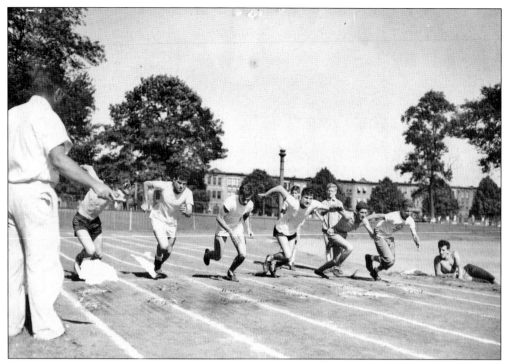

This photograph is of the 70-yard dash held at Patterson Park by the JEA. Marvin Hankin from the Spartan Club in the third lane was the winner, Charles Levitt from the Oriole Club in the sixth lane came in second, and Jack Geber from the Century Club in the first lane came in third. (Courtesy of the Jewish Museum of Maryland, 1992.231.165.)

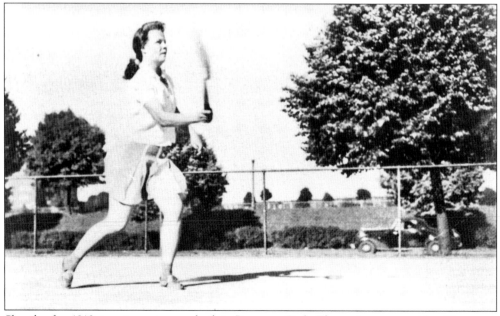

Shortly after 1910, tennis courts were built in Patterson Park. The entire eastern side of Patterson Park was dedicated to sports and recreation, with volleyball, baseball, football, swimming, and track and field. Today the same is true.

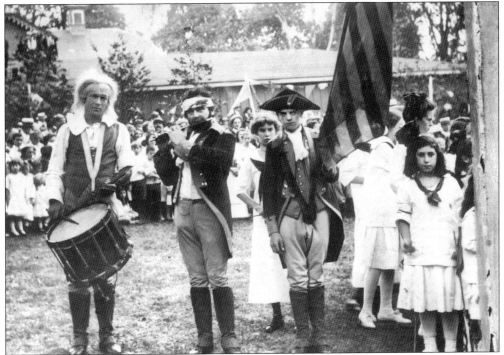

These children on July 4, 1927, dressed as a Revolutionary Army fife and drum corps. Patterson Park has always been seen as a very patriotic and historic location due to its importance during the Battle of Baltimore in 1814. New immigrants into southeast Baltimore joined in on these new traditions and celebrations.

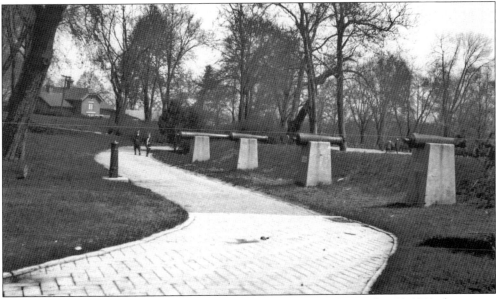

The year 1914 was the centennial of the Battle of Baltimore. On September 14, 1914, there was a large citywide celebration with parades and dedications of memorials. In Patterson Park, replica cannons were installed and a statue erected near the Pagoda to commemorate Rodger's Bastion and "The Star-Spangled Banner."

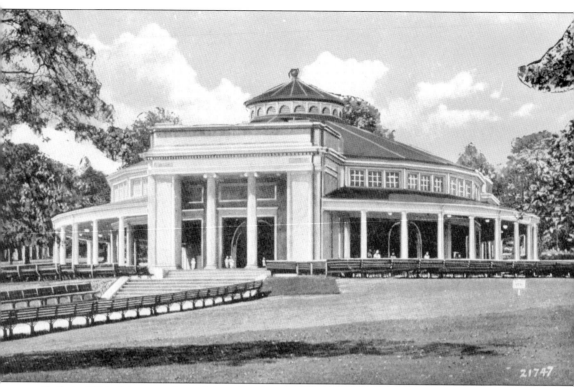

Built in 1924, this magnificent Music Pavilion was home to many live concerts and dances. In 1926, the first radio broadcasting of the park orchestra began. Concerts were on the radio every Tuesday and Friday night. This was the first broadcasted concert from any park in the country. In 1972, the Music Pavilion was burned down by arsonists.

Four

Baltimore's Best Backyard

By the 1920s, Patterson Park was complete—the western side a historic landscape with the Pagoda on Hampstead Hill and quiet, languid pathways leading to the Boat Lake, the eastern side the active and recreational side of the park for people to swim, run, and play. As the east side of Baltimore grew with industry, shipping, and manufacturing, working-class families needed facilities for sports, amusement, and relaxation. Patterson Park became their front and back yards.

The early 20th century brought a new wave of immigration into Baltimore's neighborhoods. These new Americans assimilated into the urban culture and used Patterson Park as their gym and agora. New ethnic institutions, such as churches and cultural clubs, were created inside and around the park, as were countless memories.

Among the greenery of Patterson Park, generations have relaxed in the shade of oak trees by the playground, tagged out a base runner stealing second, won first prize at the Turtle Derby, and watched their children ride their bikes without training wheels. Here are some shared moments from the Patterson Park's past, but they are very similar to so many pictures being taken today.

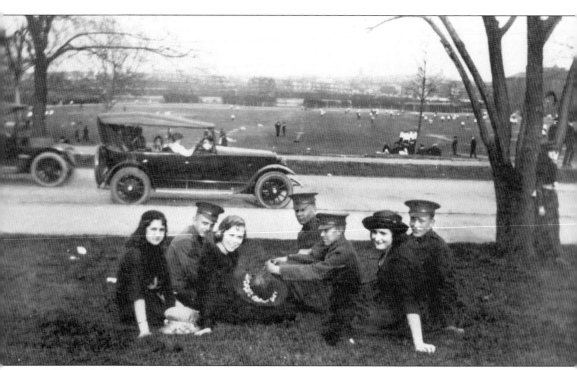

Most of the homes that surround Patterson Park are row homes. These row homes housed mainly hard-working lower- and middle-class immigrant families, who worked in the neighboring industrial factories, shops, and docks. Every section of Patterson Park's perimeter is frontage to one of these homes. Look out any window, and you will see the green of trees and lawns of Patterson Park. Here Veronica Bonczek (third from left) sits with friends near the Boat Lake overlooking the athletic fields to the east, c. 1918. (Courtesy of R. V. Miller.)

Before the use of household air-conditioning, the small neighborhood row homes that surround Patterson Park would become oppressively overheated during Baltimore's hot and humid summers. In order to escape these uncomfortable conditions, many neighborhood families slept on the park's grassy hillsides overnight. This family is on a hillside in front of the Casino in 1947. (Courtesy of R. V. Miller.)

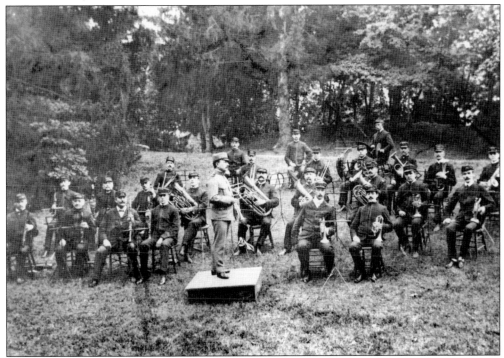

Bror Carl Bladin (1853–1910) was born in Sweden and was the father of the donor of this picture. A member of the Patterson Park Band, he is sitting in the second row, fourth from the right. Conductor Dorsey Waters stands at the podium, c. 1905–1906. (Courtesy of the Baltimore County Library, source Mrs. Almo Whittlif.)

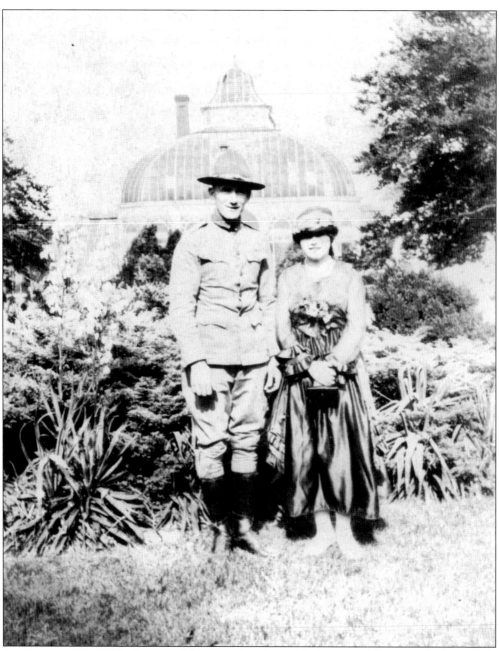

At the start of World War I, many of the recent immigrants living around Patterson Park promptly enlisted in the military. Several local families lost loved ones during this war. In 1923, a memorial flagpole was erected in Patterson Park with a plaque dedicated to all those lost in World War I—"In loving memory of our boys from East Baltimore who made the supreme sacrifice, 1917–1918." Below this inscription, all 154 soldiers lost are listed. A soldier poses with a woman in front of the Patterson Park Conservatory c. 1918. One such soldier on the plaque (not seen here) was John W. Bielatowicz, who was born in Baltimore in 1899, lived on Kenwood Avenue near the park, and was a day laborer. He was a naval seaman during World War I and his ship, the USS *Jacob Jones*, was sunk on December 6, 1917. He was killed in action. (Courtesy of the Podowski family.)

Many longtime residents recall, "There was a pathway in Patterson Park where if you skated fast enough and jumped a certain way, it would take you from the Pagoda all the way across the park to Linwood Avenue. We called the hill, "Snake Hill" because it winds all through the park." Countless children have learned how to ride a bike in Patterson Park, such as these pictured c. 1940.

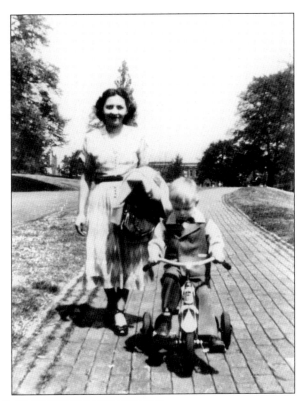

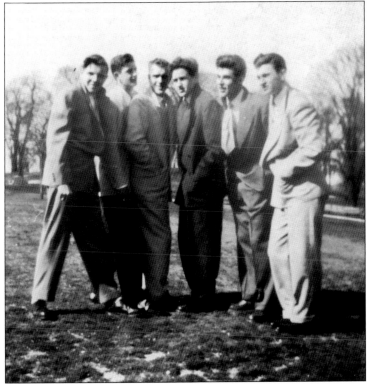

Baltimore row homes have very small backyards and no front yard, simply a series of marble steps. Patterson Park became that front and back yard to these neighbors. Patterson Park provided their pool, playground, football field, and tree to rest beneath. Even today, Patterson Park is called Baltimore's "Best Backyard." (Courtesy of Ben Podowski.)

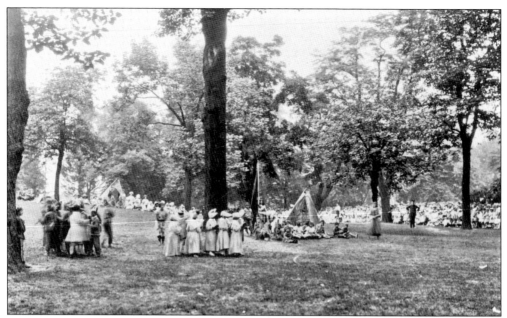

Patterson Park was becoming the central meeting place for families and the community. Events such as this Fourth of July celebration in 1923 were common in the park. Other events included Defender's Day to celebrate "The Star-Spangled Banner" and the Battle of Baltimore, ethnic parades, and the new Armistice Day.

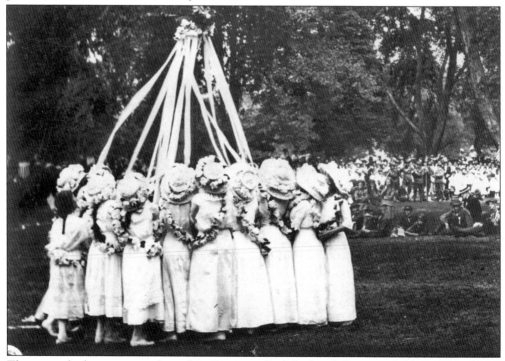

The maypole dance was performed in Patterson Park by local German children. This dance celebrates spring at the festival of May Day. Many different immigrant groups brought their traditions and celebrations to Baltimore and Patterson Park.

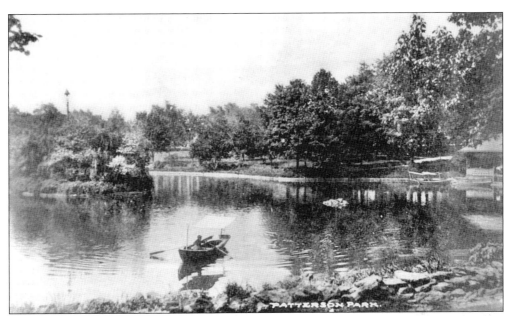

The Boat Lake was used frequently by young lovers who would rent boats from the Boat Landing and paddle around the lake. The Boat Lake has always been a gathering place for neighbors and ducks. The photograph shows a lone rower protected by a small canvas awning resting on his oars c. 1900. (Courtesy of the Baltimore County Library.)

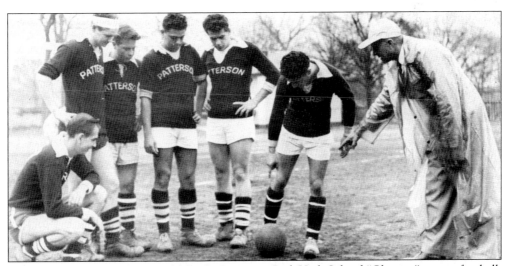

Patterson Park was the home field for the Patterson Park High School "Clippers" soccer, football, lacrosse, baseball, and track teams. Here Couch Haefner gives a few pointers to members of Patterson's championship team, from left to right: W. Knapic, J. Russ, R. Foulke, A. DiFabbio, R. Santucci, and D. Trotta. (Courtesy of the Patterson Park High School 1954 yearbook.)

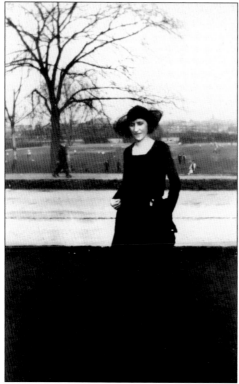

Children growing up in an industrial city like Baltimore never traveled far. The Conservatory allowed urban dwellers to see exotic plants from all over the world and gave young children an opportunity to imagine. There are many stories of children roaming the Conservatory pretending to be explorers in faraway jungles or hunting tigers. Veronica Bonczek (on the far left) is shown with friends and family near the conservatory c. 1925. (Courtesy of R. V. Miller.)

Here an unidentified young lady stands in Patterson Park c. 1918. In the background is Highlandtown (east of Patterson Park), which had been just incorporated into Baltimore City in 1919. Highlandtown was established in 1866 by German farmers. (Courtesy of R. V. Miller.)

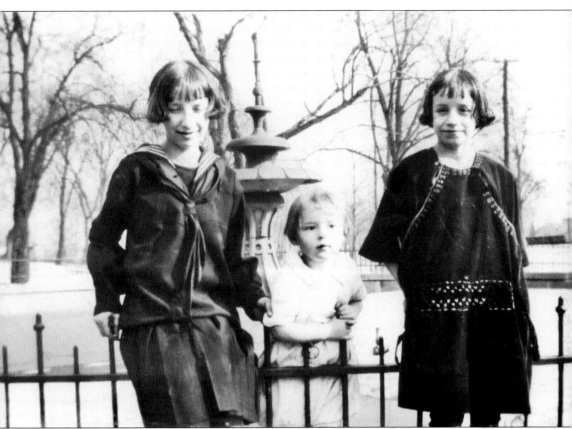

Like in most cities, in Baltimore, ethnic groups banded together into distinct neighborhoods and forged community bonds based on culture and religion. The Czech community immigrated into the Patterson Park neighborhood and became vital to the community's growth. For the Czechs (or Bohemians as they once called themselves), the local church was St. Wenceslaus, where Catholic mass was delivered in Czech. When the Soviets persecuted Catholics and later invaded Czechoslovakia, protests were held at St. Wenceslaus. In the early 1900s, the American Sokol Society was formed to maintain Czech culture and tradition. The Catholic Union Sokol teams had their national field events in Patterson Park. It was covered in the local Baltimore Czech newspaper, the *Telegraf*. The Supik family poses around the marble fountain *c.* 1925. (Courtesy of the Supik family.)

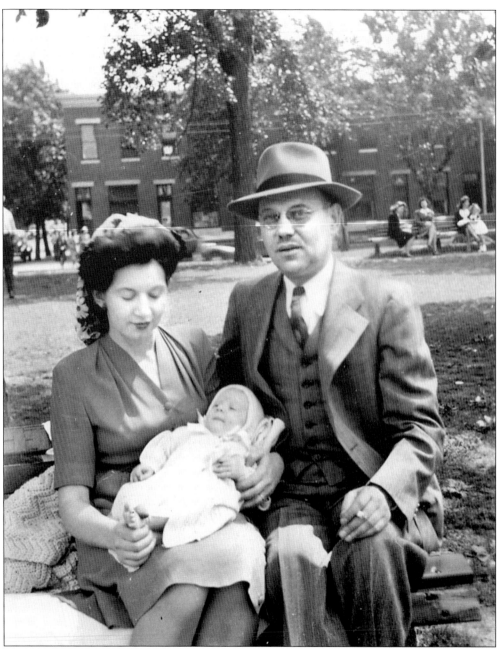

The Jewish community was very important to Patterson Park. Many immigrated to the United States from Russia fleeing poverty and tsarist and civilian pogroms. In 1903, many of Baltimore's Jewish citizens gathered to protest the Kishinev Massacre, an anti-Jewish riot in Russia. The Jewish community was able to raise money to assist the victims of this terrible atrocity. The Jewish Educational Alliance (established in 1913) was near Patterson Park, as was the Lloyd Street Synagogue (built in 1845), B'nai Israel Synagogue (built in 1876), and Hebrew Friendship Cemetery to the east. This black-and-white photograph is of Belle Berger Pliskin with her husband Rabbi Samuel Pliskin, holding their infant daughter, Debbie, in Patterson Park on May 13, 1946. (Courtesy of the Jewish Museum of Maryland, 1999.095.002.)

At the beginning of the 20th century, poverty and infant mortality was high among the recent immigrants to Baltimore. Patterson Park acted as a civic tool by providing services for the health and well-being of the community around the park. Children are shown at the playground around the 1930s.

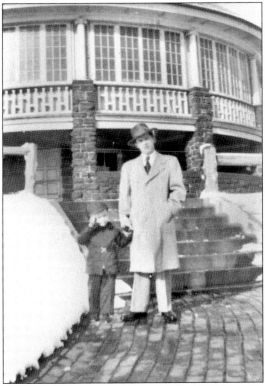

In the early 20th century, Baltimore was becoming an industrial force. Native Baltimoreans and newly arrived immigrants were finding jobs as Baltimore peaked in manufacturing. All along the Baltimore waterfront were industries like Bethlehem Steel, American Sugar, Western Electric, and the Port of Baltimore. A father and son are pictured behind the Casino c. 1940.

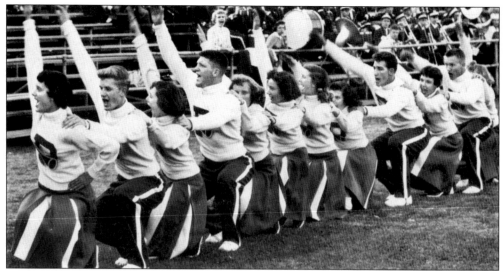

Most of the students of Patterson Park High School lived in the neighborhood, and the park became central to their lives. Patterson Park High School was located near the northeastern corner of the park at Pratt Street and Ellwood Avenue. Here cheerleaders are pepping up football fans at the new Patterson Park football field in 1954. (Courtesy of the Patterson Park High School 1954 yearbook.)

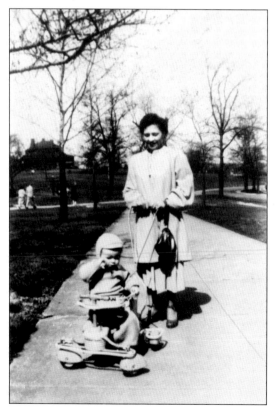

A Patterson Park visitor was quoted as saying: "On a Sunday afternoon the park was teaming with families and friends, walking through the park, watching sports games, smelling fresh flowers at the Conservatory and napping under a tree by the lake. You could spend the whole day in the park. I have many fond memories of Patterson Park." A mother and her young child are seen here strolling down a path in Patterson Park between the Boat Lake and Casino around the 1940s.

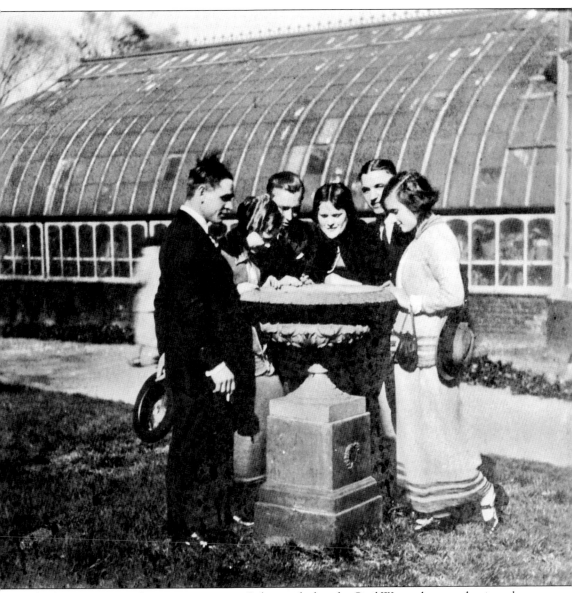

The first major wave of immigrants came to Baltimore before the Civil War and was predominantly Irish and German. Slowly these groups created their own form of nativism (favoring earlier immigrants over the newer ones) after years of being discriminated against by Baltimoreans. The second wave came at the close of the 19th and into the 20th century. These immigrants were mostly Slavs, Russians Jews, Southern Italians, Poles, and others ethnic groups from Eastern and Southern Europe. These new immigrants spoke a cacophony of languages and quickly assimilated into Baltimore's communities. Though mostly from agrarian cultures in the "old country," these workers helped to build Baltimore's industrial economy. Veronica Bonczek looks into an urn in front of the conservatory around the 1920s. Her family immigrated from Eastern Europe. (Courtesy of the Podowski family.)

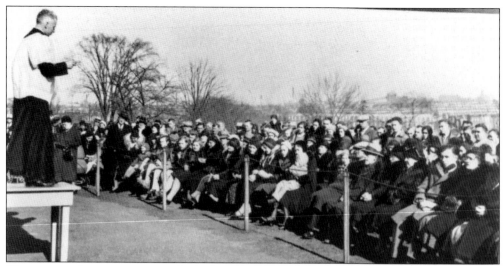

These new ethnic communities built their own churches in their neighborhoods. Southeast Baltimore is blessed with many churches: Polish churches St. Stanislaus Kostka, Holy Rosary, and St. Casimir's in Canton; Czech St. Wenceslaus; Italian St. Leo's; Jewish Lloyd Street Synagogue and B'nai Israel Synagogue; a German St. Michael's; and a Ukrainian St. Michael's church. An outdoor service is held in Patterson Park around the 1940s.

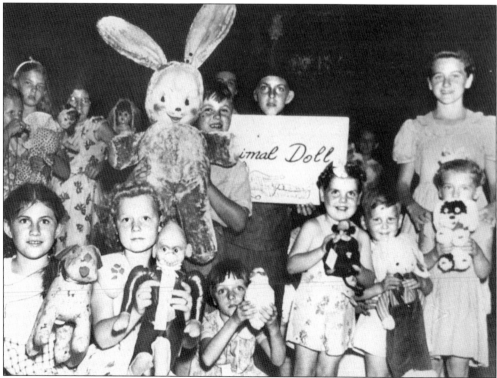

Patterson Park had many activities for young children, some of which remain today. Here is the annual Patterson Park Doll Show, c. 1950. Many of these early entries were handmade by the children's mothers and reflected their ethnic background. Other similar events were the marble championship, bike rodeo, and Halloween party. The Doll Show is still an annual event.

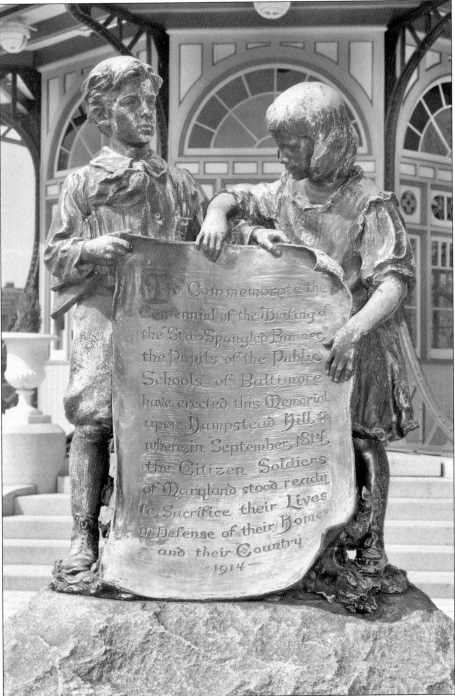

On September 13, 1914, this bronze and marble statue was erected on Hampstead Hill, in front of the Pagoda, to commemorate the centennial of Rodger's Bastion, the fortification against the British invaders built and protected by Baltimore's volunteer militia. This statue was designed and sculpted by J. Maxwell Miller from the Maryland Art Institute, and the models were two neighborhood children. (Courtesy of Anna Santana.)

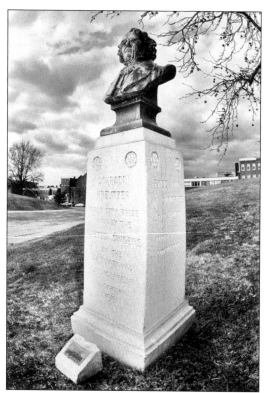

In 1915, the United Singers of Baltimore went to the National Saengerfest singing competition in Brooklyn, New York, and sang "Am Ammersee" by Langer. They won first prize and were presented with a bust of German composer Conradin Kreutzer. The statue was mounted in Patterson Park on a granite pedestal near the entrance to the park at Gough Street and Patterson Park Avenue. (Courtesy of Anna Santana.)

This picture was taken in Patterson Park (c. 1940) on the corner of Patterson Park Avenue and Baltimore Street near Butcher's Hill. This area was predominately Jewish. In 1916, the Tzemach Sedek Nusach Congregation built a yellow brick temple a few blocks from Patterson Park, and in 1919, the Bankard-Gunther mansion became the Hebrew Mansion for the Incurables. By 1925, the last of the butchers had left the area.

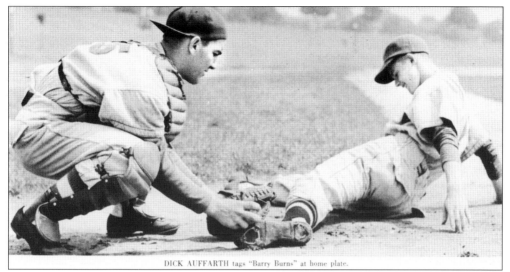

DICK AUFFARTH tags "Barry Burns" at home plate.

The Patterson Park High School baseball team had many championship years. Playing the American pastime were players like Jerry Wise, Stan Ratajczak, Richard Auffarth (seen here tagging Barry Burns at home plate), Jim Righter, and Frank Szymanski. (Courtesy of the Patterson Park High School 1954 yearbook.)

VARSITY BASEBALL

Besides baseball, Patterson Park was home field for "Pats" football, lacrosse, track and field, girls' softball, and soccer. Other sports and clubs included duckpin bowling, boys' wrestling, girls' volleyball, and even a varsity and junior varsity rifle team of sharp shooters. (Courtesy of the Patterson Park High School 1954 yearbook.)

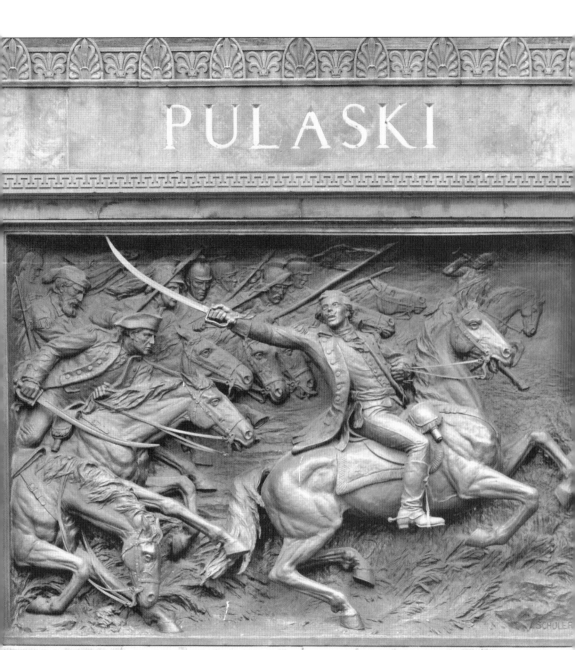

The Polish community was one of the largest ethnic groups around Patterson Park. The Poles had their own Catholic churches, newspaper (the *Jednosc-Polonia*), and social networks through clubs like the Polish Home Club and Polish League of American Veterans. In 1951, to commemorate the rich Polish history in the United States, the General Casimir Pulaski Monument was erected at the southeast corner of Patterson Park. The bronze relief statue was designed by A. Cradziszewski and sculpted by Hans Schuler. General Pulaski (1747–1779) was a Polish cavalryman recruited by Benjamin Franklin to command the American Revolutionary Army's cavalry. His "Pulaski Legion" became known for their bravery and speed. (Courtesy of Anna Santana.)

Gladys Coppage was known as Patterson Park's "Gypsy Lady." Coppage worked for the Playground Athletic League during the 1930s. She would dress in colorful dresses and glittering jewelry and roam Patterson Park telling stories such as "King Arthur and the Knights of the Round Table" and fairy tales. Children would follow her around the park listening to her stories. A young girl is seen in front of a large floral urn near the conservatory in the 1930s.

From 1926 to 1927, music was performed live on WBAL radio from Patterson Park's Music Pavilion. The Patterson Park orchestra and the Baltimore City Municipal Band played every Tuesday and Friday evening in front of an audience and for the radio station. These were the first public live radio concerts in the country. This young lady stands in front of the Conservatory c. 1935.

Another annual children's event was the Turtle Derby, where turtles were raced for prizes of toys and ribbons. Schoolchildren from around the park participated. Here a young girl pulls a cage of several turtles to be raced at the Turtle Derby, her baby brother in tow, c. 1950.

In 1925, the Taurus Fountain was removed. The bull's head was salvaged and used in a retaining wall that surrounded a new roller-skating rink near the Pagoda. That same year, Gen. Felix Angus built a shelter around where several elderly men played quoits, an English lawn game similar to horseshoes and popularized in Baltimore around the Civil War. Veronica Bonczek is shown of the far left with friends and family in Patterson Park c. 1925.

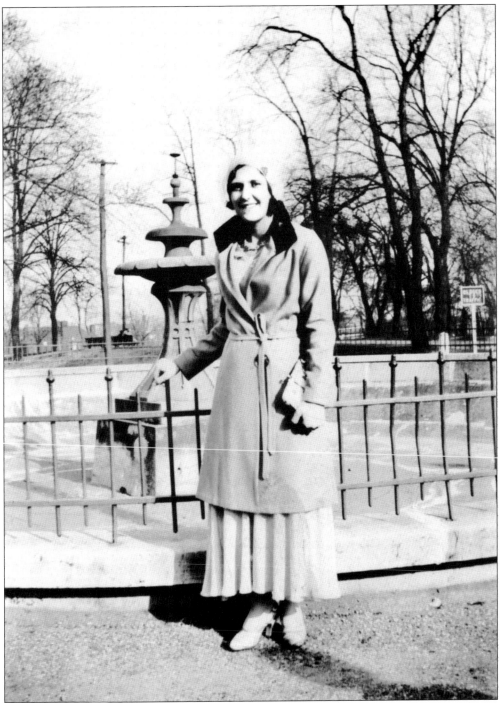

By the 1920s, Patterson Park and the surrounding neighborhoods were teeming with new cultures, languages, and customs. World War I and a new wave of nativism halted further immigration into the United States. Today the park is once again home to new cultures and customs from the countries of Latin America, Eastern Europe, and Africa. Aida Broussard Molinari is in front of the marble fountain in 1932. (Courtesy of the Supik family.)

During the 1940s and World War II, Baltimore once again flourished due to the need for manufactured goods, steel, and the heavy use of its commercial port. Slowly many of these immigrant families began to move beyond the city and their established ethnic neighborhoods. A soldier plays with his baby at the playground *c.* 1944.

Just a block to the east of Patterson Park, Eastern Avenue in Highlandtown became a busy commercial district in the 1950s with retail stores, restaurants, and theaters. This main street provided jobs for the community and a place to buy new products such as televisions and electric washers and dryers.

Seen under Patterson Park's linden trees near Ellwood Avenue, Patterson Park High School sweethearts on their way to their first class later married, started families, and worked in local businesses. Patterson Park remained important to many families. (Courtesy of the Patterson Park High School 1954 yearbook.)

In 1953, an outdoor skating rink was built. The same year, the old swimming hole was filled in and an Olympic-sized swimming pool installed. In the 1950s, the northern ballfields were dedicated to Arnold Ortmann, a beloved teacher and coach who died in a bus accident in 1948. (Courtesy of Anna Santana.)

Here is young Charles, a member of the Supik family, at age three on a park bench near the superintendent's house c. 1932. In the background is Patterson Park Avenue in Butcher's Hill. There were several businesses in the area, including Andrew Heck's Apothecary Shop. He sold "Tasteless" Castor Oil—"Pleasant to take, Children Like It." (Courtesy of the Supik family.)

Here is Elsie Supik (left) and Marie Fiore Selina (right) posing in front of the 1814 cannons near the Pagoda in 1932. (Courtesy of the Supik family.)

Children in southeast Baltimore did not have yards, so Easter egg hunts were done in Patterson Park. While many of these egg hunts were impromptu events by individual families, some of them were sponsored by local churches like St. Elizabeth's Catholic Church.

To the east of the Pagoda is a long and steep hill called Cannon Ball Hill. Generations upon generations have used that hill to ride bikes down in the summer and to sled down in the winter. This hill is what urban legends are made of, as some claim to have sledded the entire distance of the park. Children, many of whom enjoyed biking down Cannon Ball Hill, search for colorful Easter eggs in Patterson Park c. 1963.

Rosalie Podowski (left) and Veronica Bonczek are shown *c.* 1951. Rosalie is the new generation of southeast Baltimoreans coming into Patterson Park to enjoy a sunny day. Veronica surely had recounted many memories of her days in Patterson Park from the early 1920s. The relationship between Patterson Park and its community continues. (Courtesy of R. V. Miller.)

This wonderful picture is of Elva Chachulski at the playground in 1962; she lived right across from Patterson Park on Baltimore Street. The national interstate highway system began to grow in the late 1950s; as a result, there emerged an automobile-oriented flight to the suburbs. The Chachulskis stayed near their park. (Courtesy of Elva Chachulski.)

For generations, the community has gathered in the park to share a common space. People meet each other in the park that would have otherwise never met. Patterson Park was the site of many first dates. Here Edward Chachulski and Elva share a park bench in 1962. They became husband and wife. (Courtesy of Elva Chachulski.)

Seen here is Edward Chachulski in 1962. In the background stands the Pagoda, which had been slowly falling into disrepair. Often the doors were nailed shut, paint began to peel, and glass broken. In the 1950s, the Pagoda was closed and was used by police as a lookout for the park patrol. It still remained an attraction in the community. (Courtesy of Elva Chachulski.)

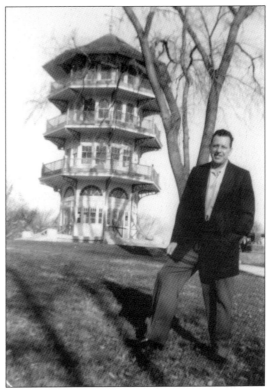

Sometimes you train the squirrels to eat from your hands and sometimes the squirrels train you to feed them on your knee. This picture was taken in Patterson Park c. 1950. Not all squirrels in Patterson Park are this tame.

The 1939 Patterson Park High School Taxidermy Club poses in front of the school. According to the 1939 yearbook, "The Taxidermy Club does the museum type of taxidermy, making habitat groups of insects, fishes, birds, and animals. The club tries to promote conservation, to instruct its members in wild life afield and in the laboratory, and to stimulate interest in the many fields of modern biology. The sponsor is Miss Hughes."

Everyone ran to the park on July 18, 1937, when a plane made an emergency landing on one of the park's baseball diamonds after losing power 2,500 feet in the air. G. B. Fenwick Jr. was able to glide his monoplane for three miles and safely landed the plane with no injuries. This picture is a collage of Patterson Park High School senior snapshots from the 1939 yearbook.

Here is a picture from the 1970s showing a hot-air balloon taking off. Patterson Park's large baseball fields were the starting point for Baltimore's hot-air balloon races. It was quite the sight to see all these colorful balloons float above Baltimore. This picture was taken from a small hill looking east toward the athletic fields.

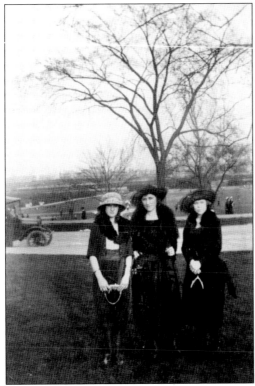

J. V. Kelley's *History of Patterson Park*, published in 1927, noted, "It [Patterson Park] is a Park upon which the wear and tear of use is heavy, and yet in season, the beauty of the place shines through—a promise of what it might be were all its users conscious of their ownership and less mindful of their right to wear it out." On the right is Veronica Bonczek (Podowski) with her family around 1920. This picture is taken from roughly the same location as the previous 1970s image. (Courtesy of R. V. Miller.)

Here is a picture of Veronica Bonczek in 1967 in Patterson Park across from St. Elizabeth's Church. Most of her life, she lived near the park and cherished the open green space the park offered. She grew up enjoying the park, and many generations have shared the same experience. Many pictures here, though taken in the past, could have been taken today. The images and sense of community still remain. (Courtesy of R. V. Miller.)

Five

DECLINE AND RENEWAL

After World War II, many returning soldiers moved their families beyond the cities to the suburbs with help from the new highway system and a prosperous economy. The suburbanization of the new American society saw flight from the city centers to new homes and communities. But not only the residents left the cities. Along with them went the revenue needed to maintain city services.

Many cities, such as Baltimore, felt the loss, and parks and recreational facilities began to suffer from deferred maintenance, shrinking budgets, and the reduction of staff. Facilities began to close, and what was once considered routine maintenance went undone. The Pagoda in Patterson Park was continually shut down and then reopened for several years, and much of the outdoor equipment was removed rather than repaired. The once well-maintained gardens faded away, and Gilded Age structures decayed and fell to vandals.

The chaotic world of the 1960s and 1970s had its effect on Patterson Park. Anger and crime entered the park. Several park buildings were burned, damaged, and defaced by vandals, and in a span of eight years during the 1970s, the bathhouse, Casino, and beloved Music Pavilion were burned by arsonists. Urban parks nationwide became more dangerous and provided fewer services. Many city governments contemplated selling off parkland to generate revenue.

Seeing their beloved parks quickly unravel, several community members came together to form associations dedicated to turning around this downward trend. In Patterson Park, neighbors worked together to breath life back into the parks, and in 1999, the nonprofit organization the Friends of Patterson Park was formed to preserve, promote, and protect Patterson Park. Working with the Baltimore City Department of Recreation and Parks, the Friends restored and renovated several historic buildings in Patterson Park, starting with the Pagoda in 2002. These capital projects signaled a renaissance in Patterson Park and surrounding neighborhoods.

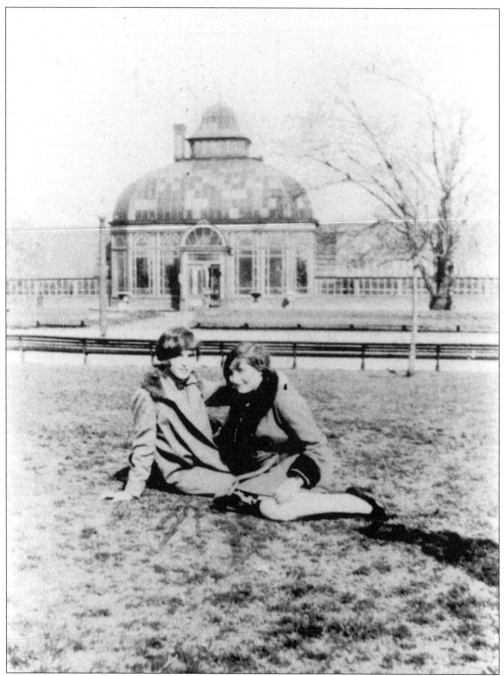

The great suburbanization occurred after World War II. More families left the urban centers and moved to newly built homes in the outlying counties. With this exodus came the neglect of city parks such as Patterson Park. The first sign of the effect was felt at the Conservatory, which had endured several years of broken glass, reduced staff, and lack of attendance; in 1948, a decision was made to raze the Conservatory before it became too dangerous and someone was injured. Later a playground was built on the site. This is a picture of sisters in front of the Conservatory c. 1935.

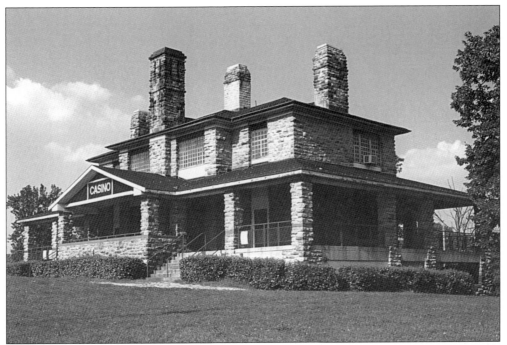

The 1960s and 1970s were a time of social upheaval with effects reaching Patterson Park. In July 1970, young arsonists set fire to the 1905 bathhouse, forever damaging the building, seen here. In 1972, it was the music hall that was burned and completely destroyed, and finally the Casino, seen here, was set afire in 1978. Fortunately it could be repaired. (Courtesy of Anna Santana.)

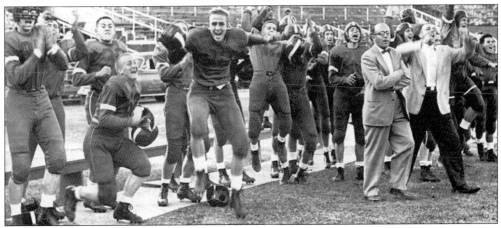

In 1952, the board of education built a large football field with bleachers and a scoreboard. In 1970 at the same location, a new football field was built and was dedicated as Utz Field after Utz Twardowicz, director of the Highlandtown Red Shield Boys Club from 1948 to 1969. In 1974, the Virginia Baker Recreation Center was built on the site of the old Music Pavilion. In light of fears of future vandalism, the new recreation center was built of solid brick with no windows. (Courtesy of the Patterson Park High School 1954 yearbook.)

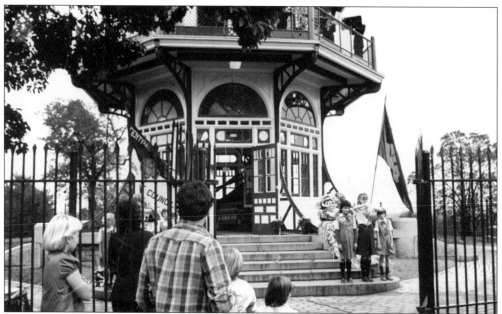

For years, the Pagoda had vacillated between decay and rejuvenation, finally being completely boarded up in 1954. In 1964, faced with the prospect of completely razing the structure, there was a campaign to restore the Pagoda, and in November of that year, it was reopened to the public. It remained open for a few years. In 1983, volunteers, rallied by local community leaders Richard Toms and Harry Rager, restored the Pagoda with donated paint and volunteer welders.

Chinese emissaries had installed two large marble "Foo" dogs at the entrance of the Pagoda for good luck. The Pagoda reopened in 1983 but unfortunately closed yet again in 1989 and remained closed for 13 years. Harry Rager (left) and Richard Toms (right) are in the background.

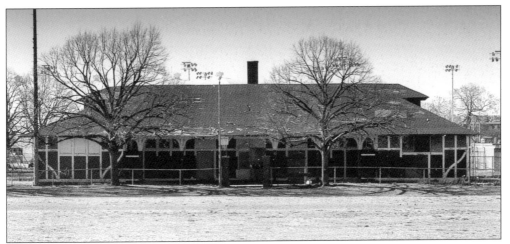

By the 1990s, other structures, such as the bathhouse, were falling further into disrepair and were community eyesores. The recreation and park staff was reduced due to the lack of a sustainable budget, vandalism was constant, perpetuating itself, and slowly the park was becoming unsafe. Old infrastructure was failing, and often the park was in complete darkness at night.

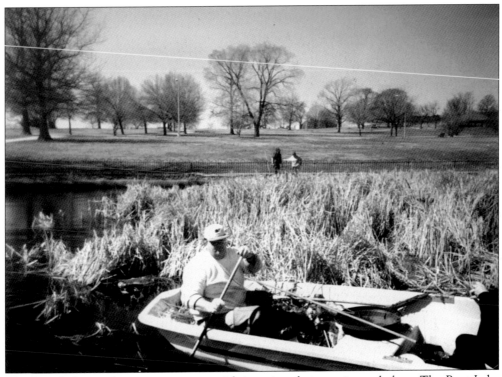

The Boat Lake was becoming overrun with invasive plant species and algae. The Boat Lake became stagnant as the water was being depleted of oxygen. Fish no longer were able to live in the water, and trash accumulated. Bob Wall is seen here cleaning trash out of the Boat Lake.

Illegal activity became common, and cars drove across the grass, causing bald spots on grassy hillsides and under trees. Graffiti was painted on playground equipment, on historic buildings, and even on trees. Vagrancy was rampant, and most neighbors never entered the park, even during the day.

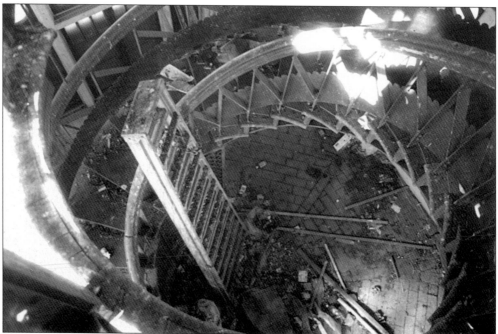

The Patterson Park Pagoda, which had for so many years been a community icon, was swiftly becoming a community eyesore. Eventually, although plywood completely enclosed the first floor, vagrants broke in, damaging the doors and windowpanes. The once multi-colored stained glass was now completely gone, and only pigeons entered the 60-foot structure. Seen here is the Pagoda's spiral staircase covered with pigeon droppings and decaying wood.

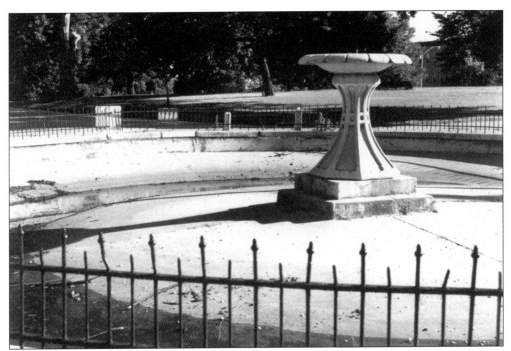

The Marble Fountain was another park feature that had lapsed into deterioration. For over 130 years, this fountain had been a common meeting place for neighbors. Now it was completely shut off and could no longer hold water. The fountain's basin was severely cracked, and the ironwork was rusted and corroded. Graffiti, mud, and trash now filled the fountain, which once had large koi and a wonderful water spray.

Volunteers once again banded together to clean up trash, remove graffiti, and to help the park in any way they could. Here volunteers are cleaning up a playground installed with help from private funds.

The surrounding community, frustrated with the poor condition of the park and its deleterious effect on the neighborhood, worked with the Baltimore City Department of Recreation and Parks to develop a plan to improve the park's facilities and to restore historic buildings. This became the Patterson Park Master Plan created in 1996.

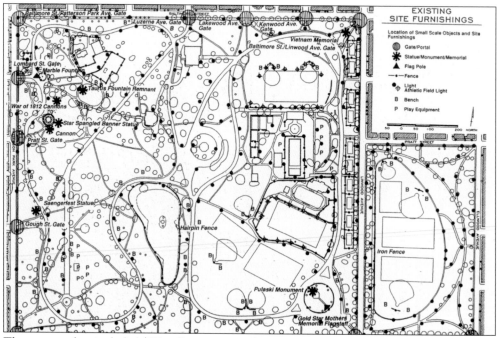

The master plan included $10 million in capital improvement projects. These projects would repair decaying recreational facilities, renovate 100-year-old buildings, and provide improved infrastructure, making the park safer and cleaner. Community dialogue was essential in the creation of the master plan.

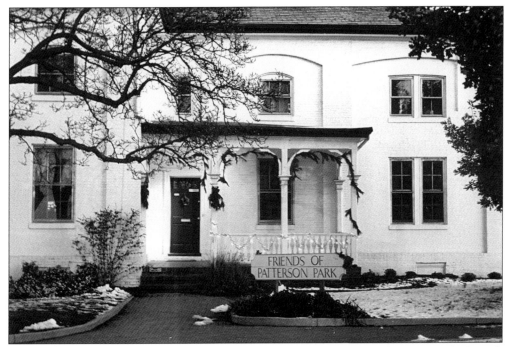

To guarantee the implementation of this written document and to advocate for these park improvements, a nonprofit organization was created to spirit the process forward. The Friends of Patterson Park was incorporated in 1998. The mission of the Friends is to preserve, promote, and protect Patterson Park. (Courtesy of Anna Santana.)

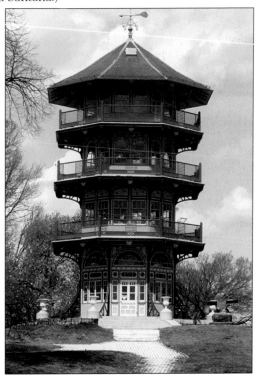

The 1891 Patterson Park Pagoda was the first capital restoration as part of this master plan, and in 2002, the Pagoda was completely renovated to its original design. Even the stained glass was authentically re-created, the weather vane fixed and remounted, and original paint colors discovered and applied to the wood and metal observatory. (Courtesy of Anna Santana.)

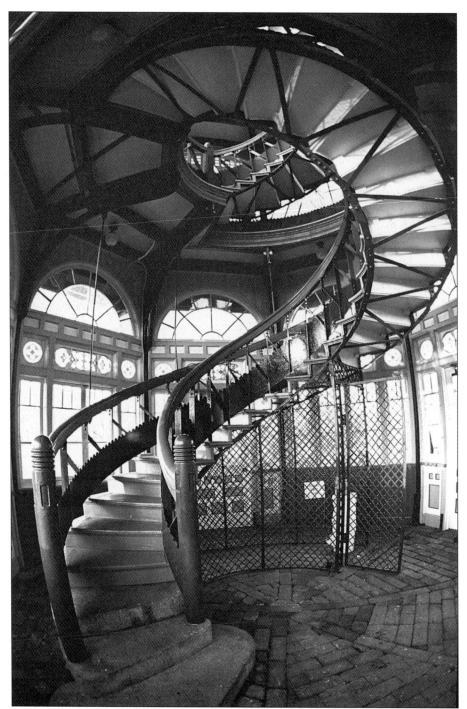

The Pagoda reopened to a crowd of 3,000 as 100 saxophone players played "As the Saints Go Marching In." The Pagoda's restoration in many ways signaled a renaissance of Patterson Park and the surrounding neighborhoods. The park's icon once again was beautiful and inviting. Seen here is the Pagoda's spiral staircase that ascends 60 feet. Notice the craftsmanship stained glass, which was completely restored to the original designs of 1891. (Courtesy of Anna Santana.)

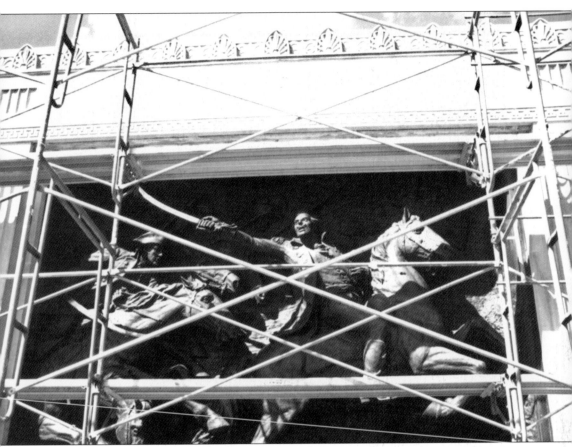

The same year, the local Polish community came together to raise money and awareness to restore their beloved Pulaski monument. The 1951 Han Schuler bas-relief sculpture was cleaned, waxed, and repaired, and new patina was applied, thanks to the Commission on Historical and Architectural Preservation and the Maryland Military Monuments Commission. Pulaski's sword had been stolen many years ago and had to be remade and remounted. (Courtesy of Anna Santana.)

The very first architectural element erected in Patterson Park was the marble fountain built in 1865, and one of the first restoration projects was to rebuild the fountain and once again make it functional. In 2003, with help from the TKF Foundation (which supports urban "greening" projects), the recreation and parks department was able renovate the fountain, seen here at the grand opening in 2004. Today the water flows from the pedestal, and it has once again become a gathering space for the community.

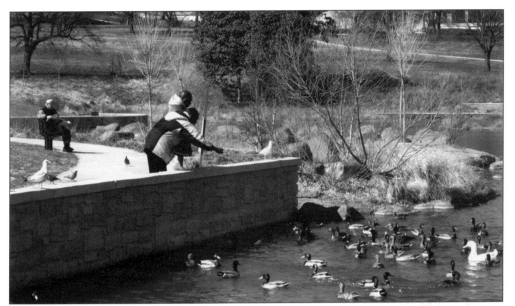

The same year, 2003, the Boat Lake was renovated. Once a weed-choked stagnant pond, the lake's restoration involved the removal of all invasive species, creation of a boardwalk, and a transformation to make the lake approachable and a wonderful environment in which to relax and appreciate the park's natural resources. Over 130 species of birds have been seen in Patterson Park. (Courtesy of Anna Santana.)

As the park has become more popular, more and more community events call Patterson Park home. Here are participants in the American Visionary Art Museum's Kinetic Sculpture Race, a race over land and water. Patterson Park is now a stage to Halloween parades, sport tournaments, Shakespeare plays, bike races, and even water ballets.

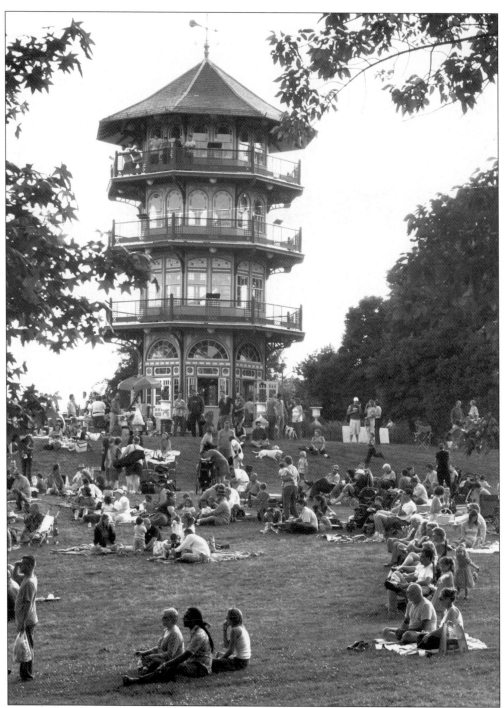

With the Pagoda fully restored, the community has once again been drawn back into the park. As they were at their inception, these revived buildings have again become a destination, a whimsical delight that people wish to visit. From its decks, 60 feet in the air atop Hampstead Hill, Baltimoreans and visitors have what many consider the best view of the city. Here over 500 people come to the hill to enjoy a concert. (Courtesy of Anna Santana.)

In 2000, the community came together to plant over 100 trees in Patterson Park at the Joseph Beuys Tree Project. Joseph Beuys (1921–1986) was a visionary German artist who planted trees in urban environments as "social sculpture." Patterson Park has several trees well over 100 years old, and many of these trees are dying. The Joseph Beuys tree planting assured a new generation of trees in Patterson Park. There were over 500 trees planted in the park from 2000 to 2005.

The community often engages in Patterson Park clean-up days organized by the Friends of Patterson Park. These gracious volunteers clean the Boat Lake, keep the Pagoda open to the public, paint park benches, water trees, and weed gardens. Here volunteers skim algae from the Boat Lake. (Courtesy of Anna Santana.)

Regrettably the community renaissance was not in time to save the old bathhouse, which was burned in the 1970s and endured close to 30 years of deferred maintenance and vandalism. The razing of this 100-year-old building has served as a cautionary tale for future preservation efforts.

Even over 150 years later, the rationale for urban parks remains the same, that is, urban parks as a common, public, and democratic green space for all to share and enjoy, an oasis to relax the body and mind, and an environmental buffer from bricks and concrete. These cannons are on the lawn by the Pagoda. (Courtesy of Anna Santana.)

The Chesapeake Bay watershed supports many species of wildlife and several maritime and fishing industries. Patterson Park is a part of this watershed. Urban parks play an important role in preserving natural resources, reducing air and water pollution, and supporting local and historic economies. This elm sits beside the Boat Lake in Patterson Park. Both are essential to our watershed. (Courtesy of Anna Santana.)

The picnic pavilion built in 1893, seen here in winter, is used every weekend for family get-togethers and community events. Patterson Park's success has affected the surrounding community. Where once stood an abandoned property with boarded-up windows, we now see a renovated family home with the next generation of park lovers. This beautiful picture is of the pavilion in winter. (Courtesy of Anna Santana.)

Several studies have shown that crime decreases in areas where there are well-maintained and well-attended parks. Patterson Park has once again become a central meeting place for the community. Neighbors connect in the park at events and on park benches. The beauty that the park possesses is at all times of day, in all seasons, and in all types of weather. A man walks along a fence in Patterson Park in the foggy morning. (Courtesy of Anna Santana.)

Patterson Park is a regional destination with national historic sites, concerts, parades, and national sporting events like Bike Jam, seen here. Such attractions bring new faces into the park and provide fun and amusement to the community that calls Patterson Park their "front yard."

As they did in the mid-19th century and into the 20th century, diverse ethnic groups are moving in the neighborhoods that surround the park. These new cultures bring smiling faces to the playgrounds, a new generation of Baltimoreans to play on the fields, and new members to our community.

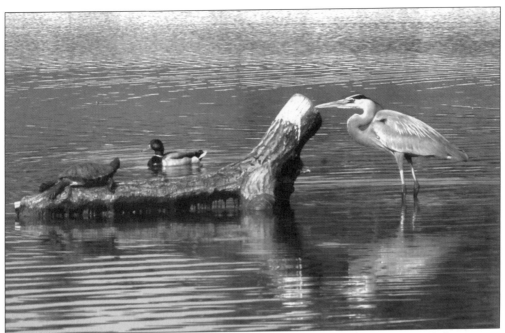

The park's natural environment is much cleaner today, thanks to everyone who helps remove trash from the park. Urban green spaces are not only for us humans; they are also important to Baltimore's wildlife. Here are some of the Boat Lake's residents: a great blue heron, a mallard duck, and a painted turtle all in one picture. (Courtesy of Anna Santana.)

Almost 100 years later, the Turtle Derby is still an event in Patterson Park, bringing many neighborhood children into the park. These children's events are made possible by the hard work and dedication of the community and of the staff of the Baltimore City Department of Recreation and Parks.

Patterson Park provides an opportunity for families to reconnect after a busy week. Here father and son go fishing at Patterson Park's Boat Lake, which is stocked with trout and bass. Neighborhood children often catch their first fish in these small waters so near to cars, bricks, and concrete. This connection with the natural environment is as important today as it was back in 1860, maybe even more important. (Courtesy of Anna Santana.)

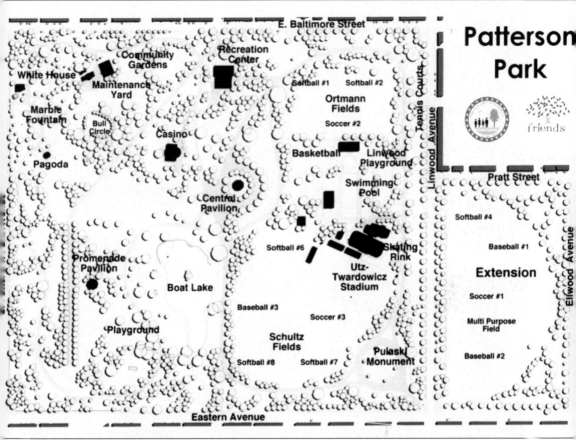

This map shows Patterson Park in 2006. Patterson Park is over 135 acres with 10 tennis courts, 10 ballfields, a pagoda, a pool, playgrounds, and miles of pathways to walk or run.

Across America, People are Discovering Something Wonderful. Their Heritage.

Arcadia Publishing is the leading local history publisher in the United States. With more than 3,000 titles in print and hundreds of new titles released every year, Arcadia has extensive specialized experience chronicling the history of communities and celebrating America's hidden stories, bringing to life the people, places, and events from the past. To discover the history of other communities across the nation, please visit:

www.arcadiapublishing.com

Customized search tools allow you to find regional history books about the town where you grew up, the cities where your friends and family live, the town where your parents met, or even that retirement spot you've been dreaming about.